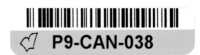

The A_{rt} *Institute* $_{of}$ *Chicago*

MUSEUM STUDIES

VOLUME 15, NO. 1

The Art Institute of Chicago Museum Studies
VOLUME 15, NO. 1

Preface

Neoclassicism dominated the arts through the second half of the eighteenth century and into the beginning of the nineteenth. In reaction to the perceived frivolity of the preceding Rococo period, the more sober Neoclassical style swept through Europe, substituting a high moral tone and formal severity for the pleasure-oriented subjects and loosely flowing lines associated with art of the court of Louis XV (reigned 1723–74). Contemporary archeological activity, including the discovery of many ancient works in excavations at Pompeii and Herculaneum and the precise measurement and study of Greek and Roman buildings, provided models for artists eager to emulate the great achievements of antiquity. Philosophical attitudes, embodied in the Enlightenment and oriented toward rationality and clarity, harmonized with the classical values of this new art movement, which promoted legible composition and simple form based on classical example. Furthermore, political change in Europe affected artistic developments; in rejecting royalist imagery and seeking a new order, the Revolutionary period in France embraced Neoclassicism and convinced recalcitrant artists to switch allegiance to the new art forms. This trend influenced the rest of Europe, too. By the century's end, Napoleon, his architects, and his designers adopted and codified Neoclassicism into a style that we call Empire. While the style remained fundamentally unchanged, the Empire period introduced a new emphasis on rich materials for furnishings and lavish decor for interiors commensurate with the grandeur of Napoleonic rule. As Neoclassicism declined in the second and third decades of the nineteenth century, its manifestations became conventional and hide-bound; new artistic visions, beginning with Romanticism, attacked and eventually replaced its hold over the public imagination.

The idea of dedicating to Neoclassicism an issue of *The Art Institute of Chicago Museum Studies* was formed several years ago in response to a small exhibition and accompanying lecture series which I organized, called "Canova and France." To present a then-new acquisition, Canova's *Bust of Paris* of 1809, French paintings, drawings, and decorative arts from the permanent collection were assembled to indicate the context that the Italian sculpture entered, upon its arrival in France. Seeing these objects together, Deputy Director Katharine C. Lee suggested that Neoclassical works in the collection would be an interesting focus for articles, and an issue was planned.

In the intervening years, this issue's contents have changed. We have had the good fortune to acquire a major period object, the *Londonderry Vase*, and to profit from the research of two visiting curators; from these timely developments, three new articles emerged to find a place in this issue. Over

all, these articles reflect the range of Neoclassicism. Studies of French, Italian, English, and Austrian objects indicate its international extent. Chronologically, the articles span the years from 1765 to 1817, generally the most concentrated period of activity in the Neoclassical style. The topics covered here encompass a number of facets particularly important to Neoclassicism: attitudes toward antiquity, the role of criticism, technical innovation in the arts, the relationships of stylistic centers and peripheries, and art as political or personal gifts. Finally, the majority of articles treat recent acquisitions. This fact may correspond to an historical phenomenon: changes in taste have revived critical and collecting interests in the period as well as led to its resuscitation as a basis for contemporary trends in architecture.

The issue opens with Malcolm Warner's discovery of English painter Joshua Reynolds's classical sources for *Lady Sarah Bunbury Sacrificing to the Graces*: Warner proposes a new reading of the portrait and clarifies Reynolds's views on the emulation of antiquity. From a single portrait, we turn next to a painting cycle by the Frenchman Hubert Robert. John Bandiera situates these canvases within traditions of architectural painting and the cult of ruins as well as in the context of contemporary attitudes toward nature. Thomas F. Rowlands's and my article on Canova's *Bust of Paris*, a gift by the sculptor to the critic Quatremère de Quincy, examines the intellectual relationship of these two leaders of the Neoclassical movement. Christa Mayer Thurman surveys fabrics printed by the new technique of the engraved metal roller. Her selection of beautiful French cottons, dating for the most part from about 1810/17, focuses on popular patterns, particularly concerning themes of love and the exotic.

The issue ends with two articles on decorative arts of the Empire period in the years 1812/14. Christian Witt-Dörring reattributes the site of manufacture of a secretary from France to Austria; in the process, he reveals the stylistic relationship of the two countries and the importance of technical innovation for furniture. Finally, Lynn Springer Roberts discusses the *Londonderry Vase* both for its importance as a major production of the Manufacture Nationale de Sèvres and also as a gift from Louis XVIII to Viscount Castlereagh on the eve of the Congress of Vienna. By the time of this event—a political landmark in the history of Europe—Neoclassicism had essentially passed its prime; the history of nations and of art moved on to new ground.

IAN WARDROPPER
*Associate Curator of European Decorative Arts,
Sculpture, and Classical Art*

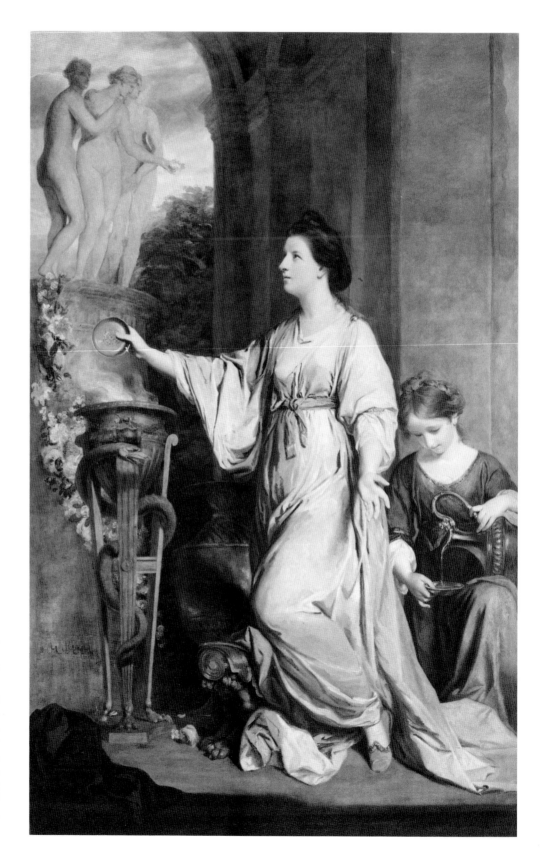

FIGURE 1. Sir Joshua Reynolds (British, 1723–1792). *Lady Sarah Bunbury Sacrificing to the Graces*, 1763–65. Oil on canvas; 242 × 151.5 cm. The Art Institute of Chicago, Mr. and Mrs. W. W. Kimball Collection (1922.4468). In this portrait by Reynolds, Lady Sarah, a celebrated beauty, is cast in the role of a devotee of the Three Graces, the companions of Venus, the Goddess of Love and Beauty.

The Sources and Meaning of Reynolds's
Lady Sarah Bunbury Sacrificing to the Graces

MALCOLM WARNER, *Visiting Research Curator, Department of European Painting*

> All the inventions and thoughts of the Antients, whether conveyed to us in statues, bas-reliefs, intaglios, cameos, or coins, are to be sought after and carefully studied. The genius that hovers over these venerable reliques, may be called the father of modern art. . . . It is generally allowed, that no man need be ashamed of copying the antients: their works are considered as a magazine of common property, always open to the publick, whence every man has a right to take what materials he pleases; and if he has the art of using them, they are supposed to become to all intents and purposes his own property.[1]

Thus in characteristically lofty tones, the first president of the Royal Academy urged his students to study and use the art of ancient Greece and Rome. Reynolds was hardly the first to offer such advice. It was a commonplace of Neoclassical artistic theory and a guiding principle followed by painters, sculptors, and architects all over mid-eighteenth-century Europe. Yet putting it into practice in Britain was another matter. For reasons religious, political, and accidental, Britain had only scantily fostered what was called the Grand Manner, in which noble and beautiful figures enacted momentous events from history, literature, the Bible, and myth. It was perfect decorum to clothe such "classics" in forms borrowed from the highest of cultures, the classical, and this had been the basis for painting in the Grand Manner as developed in Italy in the Renaissance and spread through most of the rest of Europe.

But the staple of British art was portraiture, an art that dealt with a present reality rather than the heroic past, and was regarded as inferior for that very reason. Reynolds's achievement was to forge what was almost a contradic-

tion in terms, a Neoclassical portraiture, conferring upon his British, eighteenth-century sitters an honorary citizenship in the ancient world. If not for considerations of modesty, he might have used his own portrait of Lady Sarah Bunbury (cover ill. and fig. 1) to illustrate his method of study and appropriation from classical sources at its most engaging. It is not just a case of pose-borrowing, many examples of which have been spotted and discussed by scholars of Reynolds's work.[2] It is the borrowing of an idea, a particular form of compliment found in a work of antiquity and taken as a theme for the most ingenious and delightful variations.

Lady Sarah was a celebrated beauty who attracted the attention of the young King George III when she was only fifteen; indeed he was said to have come close to proposing to her. At seventeen, she married Sir Thomas Charles Bunbury, a baronet.[3] Reynolds began his portrait of her when she was eighteen and completed it when she was twenty. Dressed in a loose, vaguely Roman costume, she is cast in the role of a devotee of the mythical Three Graces, companions of the Goddess of Love and Beauty, Venus. Standing astride a stool on which she does not quite rest her left knee, she pours a libation into a flaming tripod while looking adoringly up at a statue of the Graces on a tall altar garlanded with flowers. A slight ambiguity about the statue's position in space gives it the air of an apparition, and the central figure seems to respond to Lady Sarah's sacrifice by offering her a wreath. It is as if the statue has miraculously come to life and the Graces themselves are inviting her to join their number. The color seems to drain from the upper parts of Lady Sarah's robe as if she were meeting them halfway, becoming as marblelike in her draperies as in her flawless complexion. To the right, a younger acolyte prepares a further libation, or perhaps a bowl of water in which her mistress will wash her hands as the next part of the ritual. The scene is set against a background of simple Roman architecture opening to the trees and sky.

In 1865, the artist's biographers C. R. Leslie and Tom Taylor suggested that the figure of the acolyte was a portrait of Lady Sarah's intimate friend Lady Susan Fox Strangways.[4] The idea has proved as durable as it is implausible, leading more recent commentators to relate the inclusion of the statue to Cesare Ripa's *Iconologia*, the famous sixteenth-century emblem book, in which the Graces are presented as symbols of the joys of friendship, or "*Amicitia*."[5] As Nicholas Penny has pointed out, it would be unthinkable for Lady Susan to be cast in such a lowly role and, in any case, the Graces do not necessarily allude to friendship.[6] In fact, the source for Reynolds's leading conceit of bringing Lady Sarah into the company of the Graces, as well as for most of the classical details in the portrait, was not Ripa but Bernard de Montfaucon's vast illustrated encyclopedia of the ancient world, *L'Antiquité expliquée et représentée en figures*. Montfaucon was a Benedictine scholar of the community of St.-Maur. The initial five two-part volumes of his book were published in Paris in 1719 and five supplementary volumes were added in 1724. Reynolds probably knew the work in David Humphreys's English translation, *Antiquity explained, and represented in sculptures*, published in London in 1721–22 and 1725.

The result of twenty-six years of research, *Antiquity explained* contains thousands of images culled from every available classical source. It was the

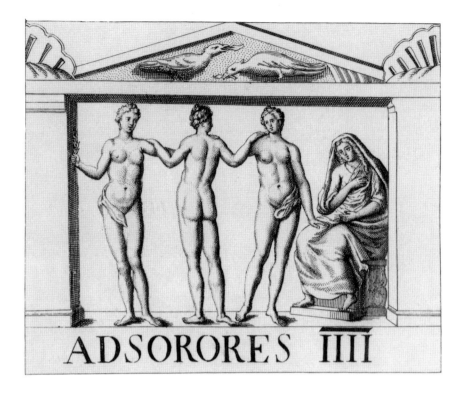

FIGURE 2. Engraving of a relief showing the Three Graces and a fourth figure. From Bernard de Montfaucon, *L'Antiquité expliquée et représentée en figures* (Paris, 1719), vol. 1, pl. 110. Note: references to Montfaucon in the text of the article are to the English translation but the illustrations are taken from the larger, clearer engravings in the original French edition.

ideal reference book for the busy artist wishing to use ideas from the antique in the way Reynolds advocated, and was surely in his mind when he extolled modern reproductive engravings, "by which, at an easy rate, every man may now avail himself of the inventions of antiquity."[7] As Montfaucon explained in his preface, his aim was to make a wealth of visual information about classical culture easily accessible in one place, saving anyone wishing to inform himself from the need to consult an unwieldy number of specialized texts. "I have reduced into one Body all Antiquity," he said, claiming that two years' study of his book would provide knowledge that would otherwise take a lifetime to acquire. It was certainly the largest corpus of engravings after classical sculpture ever assembled; despite the inclusion of many modern works and forgeries, it served as an indispensable aid to serious students of the antique for over a century.[8]

Among the images of the Three Graces in the first volume of *Antiquity explained* is a relief showing them in the company of a clothed female figure and inscribed: *AD SORORES IIII* (fig. 2). Montfaucon commented:

> Hitherto we have seen only three Graces together, now we view four, with the Inscription, *Ad Sorores quatuor, To the four Sisters*; three of which lay their Hands on each other's Shoulder, and are naked as before, and the fourth is dressed, seated, and covered with a Veil. We observed above that there were sometimes reckoned four Graces, but principally when they were taken for the *Horae*. But this is a particular Notion, and Writers are not agreed about this fourth Grace. Some say it is *Venus*; but this Figure is not only dressed, but covered with a great Veil, which we never observe in Images of *Venus*. *Bellori* imagines, perhaps with more Probability, that it is some new-married Woman, covered with her Veil; which the Graver had a mind to flatter, by placing her with the Graces, as a fourth Grace her self.[9]

9

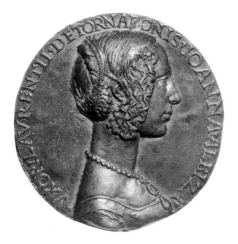
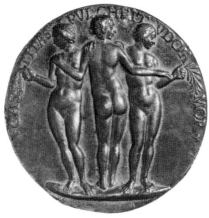

FIGURE 3a–b. Niccolò Fiorentino
(Italian, 1430–1514) (attrib.). *Medal
of Giovanna Albizzi* (obverse),
c.1486. Bronze; dia. 7.6 cm.
London, British Museum. On the
reverse are the Three Graces.

The theory proposed by the seventeenth-century scholar Giovanni Pietro
Bellori and seconded by Montfaucon, that the veiled fourth sister in the
relief may be a bride, would surely have seemed a hint worth remembering
to a portraitist frequently commissioned to paint newly-weds.[10] Lady Sarah
had been married to Sir Thomas Bunbury in the year before Reynolds began
painting her; she wears no veil in the portrait, but her wedding ring is
prominently displayed on her outstretched left hand. It was high flattery to
portray a modern English bride as a fourth Grace, but with this famously
beautiful sitter, Reynolds perhaps sensed that his golden opportunity to
revive the form had arrived.

No doubt following classical models such as the relief engraved in
Montfaucon, ladies are likened to Graces in Renaissance art and literature as
well. Certain Florentine portrait medals, for instance, show the sitter on one
side and a group of the Graces, with inscriptions, on the other. Probably the
best-known example is the medal of Giovanna Albizzi struck around the
time of her marriage in 1486 and attributed to Niccolò Fiorentino (fig. 3).
The inscription reads: *CASTITAS PULCHRITUDO AMOR* (Chastity, Beauty,
Love). Following the interpretation current in neoplatonic literature, the
medalist presented the Graces as the personifications of qualities possessed
by their mistress, Venus, and therefore, on a philosophical level, symbolic of
the threefold aspect of Supreme Beauty.[11] The implication was clearly that
Giovanna Albizzi was the mortal embodiment of those same qualities.

Montfaucon concluded his remarks on the relief by mentioning a later
medal of the same form:

> Perhaps after such an Example as this, a Medal of Queen *Katharine*
> of *Medicis* was struck, representing her with the three Graces, as
> making a fourth Grace. This might be copied from an Antique, or a
> modern Piece, and is an easy turn of Flattery.[12]

No such medal of Catherine de' Medici is known, but there is one of
Catherine de Bourbon (fig. 4), and Montfaucon may well have simply made
a slip, Catherine de' Medici having been the wife of Henri II, king of France,
and Catherine de Bourbon that of Henri II of Lorraine. Catherine de Bour-

bon's medal was struck in 1599, again commemorating the sitter's marriage, and the artist probably adapted the group of Graces on the reverse from Giovanna Albizzi's medal or a similar Florentine example. The interesting innovation lies in the inscription, which reads: *OU QUATR OU UNE* (Either four or one). Here we have the re-emergence of the idea expressed in the relief, that the sitter not only possesses qualities associated with the Graces but is herself a fourth Grace. The meaning of the inscription might be put more prosaically as follows: "There are not three Graces but four, the three of antique fame and Catherine de Bourbon, and those four are as one."

The same elegant compliment occurs in English literature. In the song of Colin to Queen Elizabeth I that forms part of "Aprill" in *The Shepherd's Calendar*, published in 1579, Edmund Spenser wrote of the Graces as dancing to the violins and voices of the Muses and imagined the Queen as joining in:

> Lo how finely the graces can it foote to the Instrument:
> They dauncen deffly, and singen soote, in their merriment.
> Wants not a fourth grace, to make the daunce even ?
> Let that rowme to my Lady be yeuen:
> She shalbe a grace,
> To fyll the fourth place,
> And reigne with the rest in heauen.

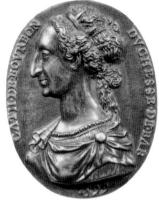

Light-hearted, charming, and hardly esoteric, the fourth Grace image may well be found in the work of other classically minded authors. By Reynolds's time, it was clearly an image with a history. He almost certainly knew it in its antique form; as we shall see, there is no doubt that he consulted Montfaucon. But whether he knew the medals, the passage from Spenser, or any other later instance is a matter for speculation. All we can say is that he was an extraordinarily learned and well-read artist, and that echoes in Renaissance art and poetry would have made such an image all the more resonant for him.

In Reynolds's view, there was no shame at all in borrowing from earlier artists, only in borrowing badly. Above all, he believed in avoiding the obvious. A borrowing might introduce into the work a subtle allusion to some venerable masterpiece of the past, but it should never strike the viewer with the hardness of a raw quotation. Indeed, for Reynolds and his audience, the delight of borrowings lay in the deftness with which they were made, and presumably all the more so in a painting to do with Graces and gracefulness. He wrote:

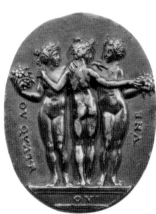

FIGURE 4a–b. French. *Medal of Catherine de Bourbon* (obverse), 1599. Silver; 5.4 × 4.2 cm. Paris, Bibliothèque Nationale. On the reverse are the Three Graces.

> He, who borrows an idea from an antient, or even from a modern
> artist not his contemporary, and so accommodates it to his own
> work, that it makes a part of it, with no seam or joining appearing,
> can hardly be charged with plagiarism: poets practise this kind of
> borrowing without reserve. But an artist should not be contented
> with this only; he should enter into a competition with his original,
> and endeavour to improve what he is appropriating to his own work.
> Such imitation is so far from having anything in it of the servility of

plagiarism, that it is a perpetual exercise of the mind, a continual invention. Borrowing or stealing with such art and caution, will have a right to the same lenity as was used by the Lacedemonians; who did not punish theft, but the want of artifice to conceal it.[13]

We see these principles at work in the ingenious "improvements" Reynolds wrought in his source for Lady Sarah's portrait. The problem with the relief was the way in which the clothed figure is upstaged by the Graces and only uneasily related to them. Lady Sarah would have looked downright silly if Reynolds had followed the same format slavishly. By representing the Graces as a devotional statue rather than in person, he was able to justify reducing their scale, to relate his sitter to them by having her perform an act of worship at their feet, and, most inventively of all, to show them apparently responding to her attentions in their poses and gestures.

The idea of staging his portrait-with-Graces as a sacrifice scene would have come easily at a time when allusion to the devotions of the ancients was virtually commonplace in European art and literature. As Robert Rosenblum has pointed out, the fashionable French painter Joseph Marie Vien produced in the 1760s several pictures of elegant young women making offerings, all of them exhibited at the Salon and popularized as engravings.[14] Moreover, the phrase "sacrifice to the Graces" seems to have been in common parlance, among the educated, as a classical expression of the very eighteenth-century principle of being polite and charming at all costs. It crops up repeatedly in the letters of Lord Chesterfield, for example.[15] So the idea would almost certainly have been part of Reynolds's mental stock, and it would have occurred to him quite naturally as he leafed through his copy of Montfaucon, a source rich in images of ancient customs. The "twist" was to bring the sacrifice idea together with that of presenting Lady Sarah as a Grace, to have his Graces return Lady Sarah's offering in kind and greet her as one of their own.

One consequence of this was that Reynolds could not simply take his group of Graces (fig. 5) wholesale from a standard classical source, even if he wished to do so, since they have almost invariably been represented with the central figure turned in the opposite direction from her companions. The two images in Montfaucon showing them facing the same way are too slight and undistinguished to have provided a model. The more important ones all show them facing alternate ways. The principal example, and probably the most famous of all antique groups of the Graces, was the one then in the Borghese collection in Rome and now in the Musée du Louvre, Paris, which appears on the same plate in *Antiquity explained* as the four Graces relief (figs. 6–7). It was unearthed only around 1608, but the composition was known in the Renaissance in other forms and Giovanna Albizzi's medal, struck around 1486, shows more or less the same group.[16]

From this canonical source, Reynolds seems to have taken the general idea of the Graces' resting their hands upon each other's shoulders and bending their knees slightly as if in a swaying motion; his central Grace holding out a wreath to Lady Sarah echoes the Grace on the right of the group as shown in the medals. Appropriately enough for one of Venus's companions, the Grace

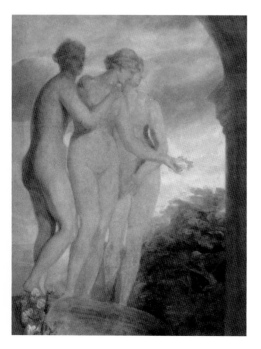

FIGURE 5. Detail of fig. 1.

FIGURE 6. Engraving of the
Borghese Graces, from
Montfaucon, vol. 1, pl. 110. Prob-
ably the most famous example of
all antique groups of the three
Graces, the work on which this
engraving is based was unearthed
only in 1608, but was known in
the Renaissance in other forms.

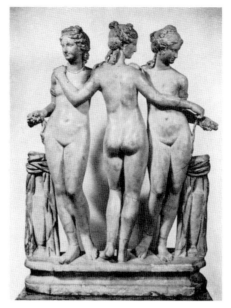

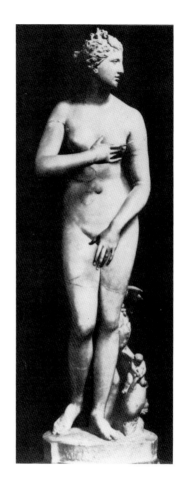

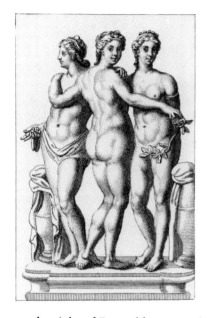

ABOVE
FIGURE 7. *Borghese Graces.*
Hellenistic. Marble; h. 150 cm.
Paris, Musée du Louvre.

RIGHT
FIGURE 8. *Venus de' Medici*,
Roman copy of Greek original,
c. second century B.C. Marble;
h. 153 cm. Florence, Galleria
degli Uffizi.

on the right of Reynolds's group is posed as one of the best-known antique sculptures of Venus herself, the Venus de' Medici in the Galleria degli Uffizi, Florence (fig. 8). For anyone familiar with the Borghese type of group, or just with the usual arrangement of Graces turned in different directions, Reynolds's variations would not only have made more sense of the leading idea of Lady Sarah's being in communion with them, but would also have enhanced the impression of the sculpture's having come alive for the occasion. We might imagine a group like the Borghese Graces relaxing their poses and elegantly rearranging themselves to complement Lady Sarah.

As far as the pose of Lady Sarah herself is concerned, scholars have rightly suggested a general debt to the Bolognese seventeenth-century painter Guido Reni, whose work was avidly collected and admired in Britain, but no exact prototype.[17] Perhaps a prototype awaits discovery in some lesser-known classical, Renaissance, or Baroque work of art. Or perhaps the pose is more or less of the artist's own invention. If the latter is the case, there are figures in the works we have already invoked for other reasons that may have played at least some part in the process. The veiled sister of the Graces in the

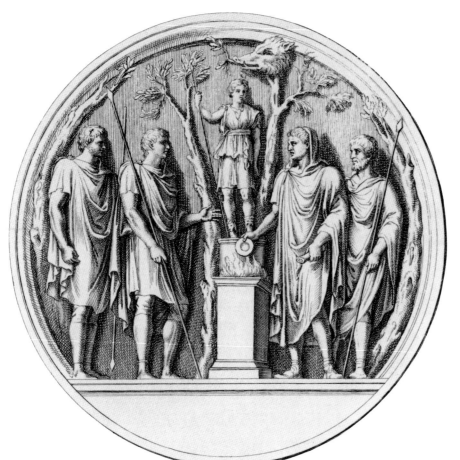

FIGURE 9. Engraving of *The Emperor Trajan Sacrificing to Diana*, a relief from the Arch of Constantine, Rome, 312. From Montfaucon, vol. 2, pl. 83.

FIGURE 10. Engraving of a tripod. From Montfaucon, vol. 2, pl. 52.

classical relief leans forward and holds her left foot up on tiptoe, as if overcome by the apparition of the Graces and unsure whether to rise to her feet or sink to her knees. Lady Sarah is upright, yet her position is similarly transitional, between standing and kneeling, and her left foot is also on tiptoe. More significantly, the way she bends her knee without actually kneeling means that her stance gently echoes that of the Graces. The Grace on the left of the Borghese group, for instance, is also resting her weight on the right leg while bending the left knee, though less sharply than Lady Sarah. Reynolds seems to have invited this general comparison by giving a side view of his own left Grace that emphasizes her bending knee, which appears as a mirror image of the sitter's.

For the trappings of the sacrifice, Reynolds turned to the compendious treatment of ancient sacrifices in the second volume of Montfaucon, who seems to have had a special interest in the subject. Montfaucon's illustrations include a number of libation scenes that the artist may have drawn upon, some with altars surmounted by statues like his altar of the Graces. The closest example is probably the circular relief from the Arch of Constantine showing the Emperor Trajan sacrificing to the goddess Diana (fig. 9). "Sacrifices may be distinguished into two sorts; bloody and unbloody," Montfaucon wrote. "The first, an Immolation of brute Animals, and in some Countries of Men; the last, an Offering of things without Life, as of

Wine, Fruits, Corn and Incense."[18] Lady Sarah's sacrifice is of the second sort, her libation presumably consisting of some kind of fragrant oil.

Elsewhere, Reynolds's dependence upon *Antiquity explained* was more specific. In spite of some variations of design, it is evident that he adapted the flaming tripod onto which Lady Sarah pours her libation from one of Montfaucon's illustrations in the same section on sacrifices (fig. 10). There are just some changes of detail and one major Reynoldsian improvement on the antique original: a serpent that was wound tightly around one leg of the tripod curls itself more loosely around all three in his version. As if following the Graces' example, it appears to have come alive, and to be glaring angrily, perhaps enviously, at Lady Sarah or her acolyte. According to Montfaucon, sacrificial tripods were all modeled upon the one in the Temple of Apollo at Delphi, and many followed that example in featuring a serpent in the design as an allusion to Apollo's slaying of the python.[19]

The box in the lower left corner, partly covered by drapery, is another archeological touch taken from Montfaucon's illustrations of sacrificial objects (fig. 11). It is an *acerra*, "a kind of little Chest or Box, in which they put their Incense and other Perfumes."[20] The vessel from which the acolyte is pouring out the next libation, known as a *praefericulum*, is from the section on sacrifices in the supplement to volume two of *Antiquity explained* (fig. 12). Reynolds included only the upper half with its distinctive lion decoration and allowed the satyrs' heads on the sides, which Montfaucon identified as signs that the vessel was used in Bacchic rites, to be obscured by the acolyte's hand and knee. The stool at Lady Sarah's feet does not appear in Montfaucon as such, but Reynolds may well have transposed the lion from the *praefericulum* and invented the scroll decoration above its head. The *patera* from which she pours her libation and the large vase behind her are typical rather than derived from any particular examples.

Having followed Reynolds's train of thought from the appropriation of his idea to its elaboration in the portrait, "with no seam or joining appearing," we should consider the question of what the work says about Lady Sarah Bunbury. Upon which particular qualities was Reynolds complimenting her? To modern taste, the idea of casting a young Englishwoman as the fourth Grace may seem slightly absurd, and it is tempting to "excuse" Reynolds by regarding the absurdity as deliberate, in other words, to read the portrait as mock-heroic.[21] We all know, as Reynolds's audience knew, that the scene is make-believe and the compliment overstated. But the mock-heroic deals in a far more pronounced mismatch of form to content. A mock-heroic portrait would be one in which the trappings of greatness made the sitter look ignominious, as in Reynolds's early parody of Raphael's *School of Athens* with likenesses of English *milordi* in Rome.[22] With Lady Sarah, we are surely meant to read the casting as with rather than against type, the overstatement as charming rather than ridiculous. We take the image to reflect some of the qualities the lady possessed though not their exact measure, expecting a degree of exaggeration as testimony to the great fondness she commanded in her admirer. "Thus," wrote Edward Edwards, "he introduced into his portraits a style of gallant compliment, which proved that as a painter he well knew how to ensure the approbation of the distinguished fair."[23]

FIGURE 11. Engraving of an *acerra*. From Montfaucon, vol. 2, pl. 55. In his portrait, Reynolds included a number of antique vessels and artifacts such as an *acerra* (shown here), a *praefericulum* held by the acolyte, and a *patera*, from which Lady Sarah pours her libation.

FIGURE 12. Engraving of a *praefericulum*. From Montfaucon, suppl. to vol. 2, pl. 13.

The Graces were associated with a number of good qualities, all of which we understand also to have been Lady Sarah's. The Graces were always said to be the companions or handmaidens of Venus, and in most accounts her daughters. The role of Grace, follower of the Goddess of Love and Beauty, could hardly be more fitting for a famous beauty who had just been married. Indeed, Reynolds may have intended gently to liken his sitter to Venus herself. As we have seen, Montfaucon said that some scholars interpreted the fourth figure in the classical relief as Venus, and such a reading was bound to occur to the learned spectator before a composition with the three Graces and a fourth female figure, even if strictly incorrect. With the Guido Reni-like treatment of the sitter's pose and expression, the portrait of Lady Sarah may well have triggered recollections of that artist's *Venus Attired by the Graces* (fig. 13), a composition Reynolds knew and mentioned in one of his *Discourses*.[24] If it did, both he and his client could only have been pleased.

Renaissance philosophers saw the Graces in the same relation to Venus as the Holy Trinity to God, embodying the three aspects of the Deity: Beauty and Love were essentials, and the third could be Chastity or Desire according to the circumstances.[25] The idea would be difficult to adapt to four Graces instead of three, and in any case the meaning of the Graces in Reynolds's time was softer and more variable. The seventeen different, interconnected, and overlapping definitions of the word "Grace" in Samuel Johnson's *Dictionary* are an indication of this. Montfaucon gave some of the associations of the Graces, but his main interest lay in the variety of ways in which any given subject had been represented in art, rather than its meaning.

For a fuller extrapolation of the symbolism of the group, we can turn to another French text that had relatively recently been translated into English: Antoine Banier's *La Mythologie et les fables expliquées par l'histoire*, published in London in 1739–40 as *The Mythology and Fables of the Ancients, Explain'd from History*. This is a representative work rather than one we know Reynolds to have consulted, but Banier's stress upon the popularity of offerings to the Graces would certainly have encouraged the artist in his idea of showing Lady Sarah making a sacrifice:

> Among the many Divinities invented by the Ancients, none were more amiable than the *Graces*, since it was from them the Rest borrowed their Charms, Sources of every Thing agreeable and smiling in Nature. They gave to Places, Persons, Works, and to every thing in its kind, that finishing Charm which crowns all its other Perfections, and is as it were the Flower of its Excellence: In fine, it was only from them a Person could derive that Talent, without which all other Qualifications are lost; I mean the Talent of pleasing. Accordingly of all the Goddesses, none had a greater Number of Adorers than they. To them all Ranks, all Professions, Persons of every Age and Character address'd their Vows, and offered Incense.[26]

As a Grace, then, Lady Sarah would be possessed not just of divine beauty but of the very essence of charm. She would be both lovely and loved.

She would be natural too. It is no accident that Reynolds shows her three sister Graces as set apart from the man-made surroundings of their temple,

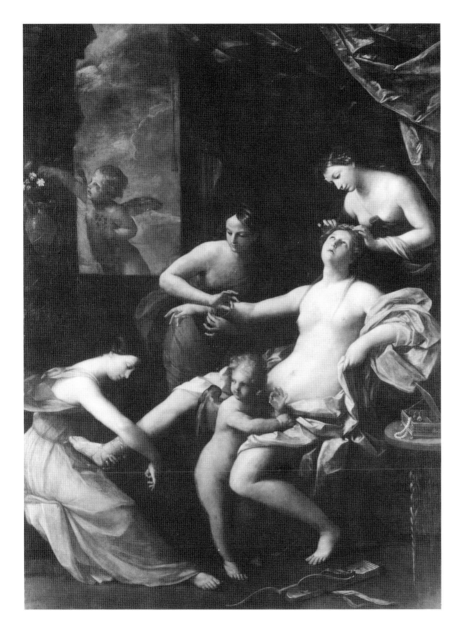

FIGURE 13. Guido Reni (Italian, 1575–1642) (studio of). *Venus Attired by the Graces*, 1622. Oil on canvas; 282 × 206 cm. London, National Gallery.

occupying a slightly ambiguous position in space, against a background of trees and sky rather than architecture. They are associated with natural things, the wreath that one of them hands to Lady Sarah and the cornucopic swag of flowers that cascades down their altar. They are also nude, a feature of their iconography seen since classical times as symbolizing naturalness and sincerity. Montfaucon took up this theme in *Antiquity explained*, laying stress upon the idea that true Grace comes from within: "They who will draw a moral Sense out of this, will say it signifies the true Graces ought to be in Things or Men themselves, and not borrowed from any exterior Ornaments."[27]

Though agreeing in principle, the Abbé Banier could see the point of a little gilding on the lily:

> At first these Goddesses were represented only by mere Stones that were not cut; and such were the ancient Statues, as has been already remark'd elsewhere. But they came very soon to be represented under human Figures, clad in Gauz in the early Times, and afterwards quite naked. *Pausanias* owns that he could not trace the Time when the Custom of giving them Drapery came to be laid aside. They were thus represented, to signify that nothing is more amiable than simple Nature; and with a thin plain covering of Gauz, to intimate to us that if sometimes Art be induced to assist Nature, foreign Ornaments ought to be employed only discreetly and with Reserve.[28]

There were several reasons why Reynolds liked to dress his sitters in simple, loose-fitting costumes. They recalled classical sculpture and Renaissance painting, bestowing the aura of the Grand Manner upon both sitter and portrait. They would never appear dated, because they stood outside fashion. But in their simplicity, and in the way they seemed to follow the forms and movements of the body rather than constricting them, they also suggested that crucial *desideratum* of the eighteenth century, the quality of naturalness. Lady Sarah could hardly join her sister Graces in their nudity or be shown skimpily dressed in gauze, but her relatively plain costume was a gesture in that direction. Banier's idea of graceful dress as a discreet touch of Art in the service of Nature was one with which Reynolds would surely have agreed.

Yet the significance of the Graces went even beyond beauty, charm, and naturalness. "The most noble of all the Prerogatives of the Graces was, that they presided over Kindnesses and Gratitude," wrote Banier, "insomuch that, in almost all Languages, their Names are made use of, to express both Gratitude and Favours." He went on to explore the idea in some of its ramifications:

> First they were called *Charites*, a Name derived from the *Greek* Word that signifies *Joy*, to denote that we ought to have an equal Pleasure in doing good Offices, as in shewing Gratitude to those from whom we have them. They were young, to teach us that the Memory of a Favour ought never to decay; sprightly and nimble, to shew that we must be prompt to oblige, and that a Favour ought not to be long deferred. Accordingly the *Greeks* had a Way of speaking, that a Favour which comes lingeringly ceases to be a Favour. They were said to be Virgins, to give us to understand, first, that in doing good, our Views ought to be pure, the Want of which marrs the Favour; and in the second Place, that the Benificent Disposition ought to be accompany'd with Prudence, Reserve and Discretion.[29]

To give is to receive, and to receive is to give—this had been the moral of the Graces since Antiquity, and their relations to one another had been allegorized in any number of different senses to do with favors and thanks. The

way they are normally represented as linked together by touches and embraces was read as showing how giving and receiving are inseparable. Sometimes each Grace stood for a different act, giving, receiving, and exchange, as with Ripa's reading in the *Iconologia*, where he invoked the Graces as emblems of the joys of friendship. Sometimes their usual arrangement with the central one facing in the opposite direction from her sisters stood for the idea that what we give will be returned to us in double measure.[30]

As in Spenser's poem, the Graces sometimes danced in a circle, and Banier's reading of this aspect of their iconography seems again to be especially useful as we look at Reynolds's painting:

> They danced in a Circle, to intimate that there ought to be among Mankind a Circulation of Kindnesses; and moreover, that by Acts of Gratitude, the Favour ought, according to the Order of Nature, to return to the same Source from whence it was derived.[31]

The four Graces of the portrait, Lady Sarah and her three sisters on the altar, are not actually dancing in a circle. But the arrangement Reynolds invented for them, facing each other and exchanging gifts, does echo Banier's idea of "a Circulation of Kindnesses." Unlike earlier Graces, these four are actually shown giving and receiving. Lady Sarah gives a libation and the Graces reciprocate with their wreath; they receive her homage, and she receives their invitation to join them. Holding out her *patera*, she repeats the gesture of the central Grace holding out the wreath, and it is apposite that the rhyming forms of *patera* and wreath are circular. For Reynolds's conceit is circular. Lady Sarah gives to the goddesses of liberality and, in so doing, shows herself to be like them. The Graces acknowledge her with the gift of sisterhood, which she receives with the gratitude of a true Grace. Blessed with beauty, charm, and naturalness, she returns the favor by being generous herself, and so on. We now see what Reynolds meant when he spoke of borrowing from the art of the past as "a perpetual exercise of the mind, a continual invention." He did more with his sources than merely disguising them and adapting them physically to their new purpose; he enriched their meaning and "improved" them, exactly as he said artists should. The ingenious result invites an ingenious reading.

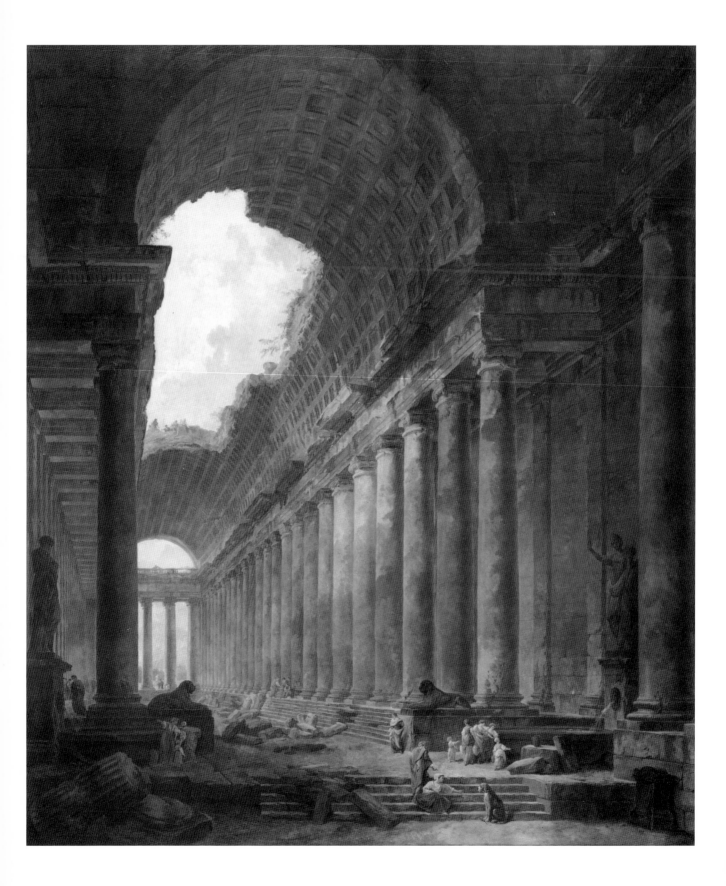

Form and Meaning in Hubert Robert's Ruin Caprices: Four Paintings of Fictive Ruins for the Château de Méréville

JOHN D. BANDIERA, *McGill University, Montreal*

Hubert Robert (1733–1808) was the foremost French practitioner of ruin painting during the period in which it reached the zenith of its popularity.[1] In the second half of the eighteenth century, as the fascination with the antique grew to amazing proportions in France and throughout Europe, so too did the cult of ruins and, concurrently, the French school of ruin painters. Robert, called "Robert des Ruines" by his contemporaries, achieved an especially high degree of success with his evocative images of the decayed remnants of ancient civilizations.[2] His patrons came, for the most part, from the ranks of fashionable antiquarians who desired to be both entertained and edified by his depictions of ruined classical architecture which, though they were frequently capricious, bore a cachet of archeological sophistication unmatched by the works of any other ruin painter. He elevated ruin painting to an unprecedented level of prominence in terms of patronage and critical acclaim, and he is unquestionably the central figure in any study of this significant aspect of Neoclassical art.

Our present-day view of Robert's achievement is clouded by the fact that the cult of ruins was a short-lived cultural phenomenon that is not readily comprehended by twentieth-century minds. Robert's works are now prized by private collectors and museums but, ironically, his art-historical reputation is not as great as his sustained popularity would suggest. In part, this is because his works are so numerous and consistently likable—factors that can, depending on one's point of view, lend support to the mistaken idea that they are without substance. Certainly there is a prevalent scholarly misperception that French ruin painting, when compared with history painting, is a facile, decorative, and mostly derivative mode. This situation, however, is largely due to oversight as students of French eighteenth-century painting (exhibiting a bias reminiscent of the anachronistic doctrine of the hierarchy of the genres) have not striven to reveal

FIGURE 1. Hubert Robert (French, 1733–1808). *The Ancient Temple*, 1787. Oil on canvas; 256 × 223 cm. The Art Institute of Chicago, Gift of Adolphus C. Bartlett (1900.382). This painting was one of four works (see also figs. 2–4) depicting ancient monuments and commissioned from Robert by Jean Joseph de Laborde to decorate his chateau at Méréville.

RIGHT
FIGURE 2. Hubert Robert. *The Obelisk*, 1787. Oil on canvas; 256 × 223 cm. The Art Institute of Chicago, Gift of Clarence Buckingham (1900.383).

MIDDLE
FIGURE 3. Hubert Robert. *The Fountains*, 1787 or 1788. Oil on canvas; 256 × 223 cm. The Art Institute of Chicago, Gift of William C. Hibbard (1900.385).

FAR RIGHT
FIGURE 4. Hubert Robert. *The Landing Place*, 1788. Oil on canvas; 256 × 223 cm. The Art Institute of Chicago, Gift of R.T. Crane (1900.384).

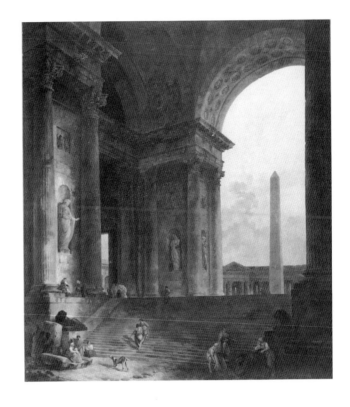

degrees of innovation, high-mindedness, and profundity in Robert's oeuvre that they routinely and enthusiastically ascribe to historical painters of comparable and even lesser ability. By contrast, the intent of the present article is to take a fresh look at Robert's art in its proper cultural context. A probing analysis of four pictures of fictive ruins and architecture in the collection of The Art Institute of Chicago will serve to illuminate his singular contribution to the development of a grand manner of Neoclassical ruin painting that is rich in erudite references and ennobled by sobering moral allusions.

Before our field of vision can be expanded, we must consider the historical particulars of the works being studied and familiarize ourselves with some salient aspects of Robert's life and career. In 1787, Robert, who by this time was the most prominent painter of architectural subjects in France, was commissioned by the exceedingly wealthy financier and entrepreneur the Marquis Jean Joseph de Laborde to paint a suite of four canvases for his chateau at Méréville near Etampes. The imposing paintings, *The Ancient Temple*, *The Obelisk*, *The Fountains*, and *The Landing Place* (figs. 1–4), were intended for the embellishment of the small salon (*salon d'hiver*) and, as

inscriptions on two of them indicate, they were executed in 1787 and 1788 (it is virtually certain they were installed in 1788).[3] They are first-rate pictures but, interestingly, Robert's work at Méréville as a painter is overshadowed by his contribution there as a garden designer.[4] As the embodiment of the "painter-gardener," an artistic hybrid frequently encountered in the eighteenth century, Robert moved easily between the worlds of two- and three-dimensional illusionism; he was a member of the Académie royale de peinture, having been admitted in 1766 as a "Peintre de l'architecture et des ruines (Painter of Architecture and of Ruins)," and he also held the title of "Dessinateur des Jardins du Roi" (Designer of the King's Gardens), bestowed upon him in 1778.[5] It is not surprising, therefore, that he was called upon in 1786 by the Marquis de Laborde to supervise the transformation of his formal garden at Méréville into what would become one of the most renowned examples of the *jardin anglais* (English-style garden). After his plans for the garden complex were completed, Robert executed six paintings for the chateau, two views of the park for the billiard room, and the four pictures that are the focus of this study.

22

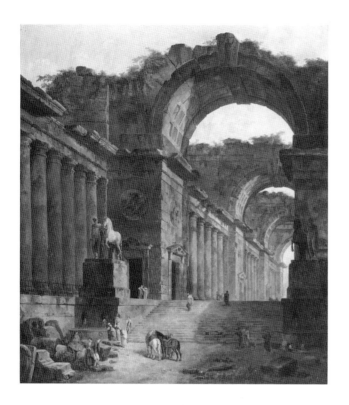

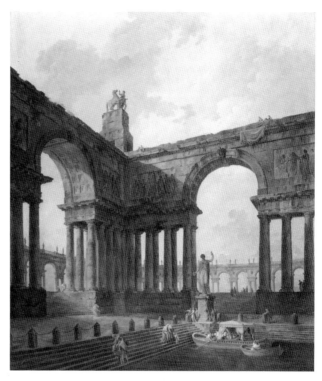

These four works exemplify Robert's mature style. Their vocabulary of architectural forms (colonnades, arches, coffered vaults, niches, and majestic stairways) in varying states of dilapidation and in conjunction with learned quotations of Roman statuary can best be described as Robert's "stock-in-trade"; it was with works such as these that he had established his considerable reputation. These paintings treat themes, inspired by ancient Roman architecture, that had preoccupied him for many years and that he had repeatedly returned to in paintings and drawings. There are, for example, other depictions (see fig. 5) of majestic ancient ports like the one seen in *The Landing Place*. There are also numerous representations of ruined antique galleries (one of his favorite subjects) that predate *The Ancient Temple*, among them a strikingly similar drawing (fig. 6) executed in 1780.[6] As early as 1767, Robert's *Grand Gallery Illuminated from Behind* (location unknown), which anticipated the imposing treatment of the grand gallery theme in *The Ancient Temple* by twenty years, inspired one of Denis Diderot's most eloquent meditations on the metaphysical implications of ruins.[7] Shortly thereafter, by the early 1770s, Robert reached full artistic maturity with

works such as *The Discovery of the "Laöcoon"* (fig. 7), in which he deftly combined elements derived from ancient Roman sources and fully exploited the potential of the grand gallery motif for high illusionism and sublime effect. In light of Robert's earlier achievements, then, the paintings for Méréville are best appreciated as reprises of successful iconographic formulas and as continuations of a tradition of heroic ruin caprice painting of which Robert was the acknowledged master.

The paintings also fit comfortably under the broad rubric of Neoclassicism. All four are representations of classical ruins and, as variations on a common theme, all are fantastic combinations of elements drawn from the art and architecture of ancient Rome. Indeed, though they were executed in the 1780s, they reflect Robert's direct exposure to the cultural ambience of Rome in the 1750s and 1760s, when that city was the center for the development of a new aesthetic seeking the inspiration for its formal language in antiquity. In 1754, Robert left Paris for Rome in the retinue of the French ambassador, the future Duc de Choiseul, remaining there for over ten years, during which time the orientation of his art was determined. He took up residence in 1759 as an official *pen-*

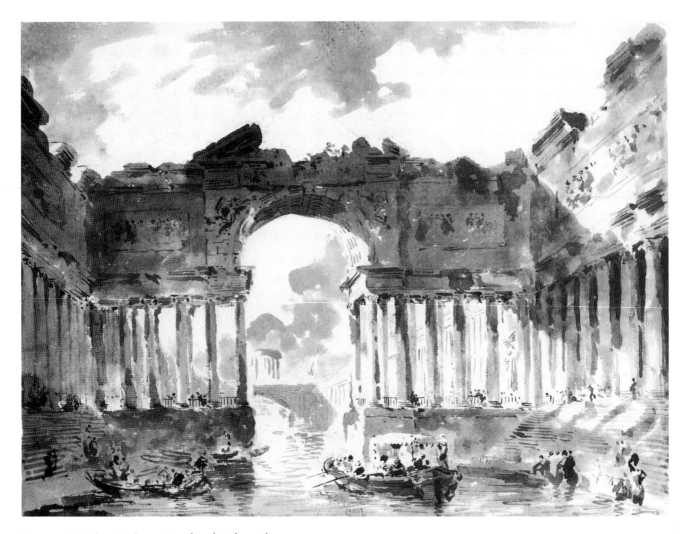

FIGURE 5. Hubert Robert. *Canal and Colonnade*, n.d. Pen and wash on paper. Montpellier, Musée Fabre. Photo: Bulloz. Themes inspired by ancient Roman architecture, such as this view of a majestic port, preoccupied Robert for many years.

sionnaire (government-sponsored student) at Palazzo Mancini, the Académie de France à Rome, where he joined a community of young painters and architects who were greatly inspired by the revelations offered by the fledgling science of classical archeology and who sought to reform and reinvigorate modern art through the observation, emulation, and interpretation of the art of the ancient world.

He also benefited from his personal contacts with established leaders of the Neoclassical avant-garde, among them Giovanni Battista Piranesi (1720–1778), who was an artist as well as a precocious archeologist.[8] Piranesi's response to the antique, at one and the same time empirical and visionary, had a significant effect upon Robert, who became an equally assiduous student of the material culture of ancient Rome. In a combined spirit of scientific and romantic enquiry, he executed innumerable studies of the ancient sites and monuments of Pompeii, Herculaneum, Rome, etc. These were later put to use as his "inventory" of subject matter and imagery, and they also became the wellspring for his (often outlandish)

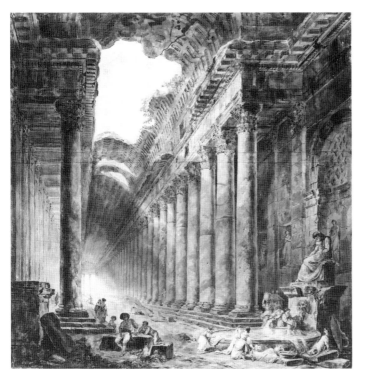

FIGURE 6. Hubert Robert. *Ruins of an Ancient Temple*, 1780. Pen and watercolor on paper; 80 × 77 cm. Lille, Musée des Beaux-Arts. Photo: Giraudon.

FIGURE 7. Hubert Robert. *The Discovery of the "Laöcoon,"* 1773. Oil on canvas; 119.4 × 162.6 cm. Richmond, Virginia Museum, The Glasgow Fund (1962.31). The *Laöcoon*, a famous sculpture from antiquity, was rediscovered during the Renaissance and inspired many artists throughout the sixteenth, seventeenth, and eighteenth centuries.

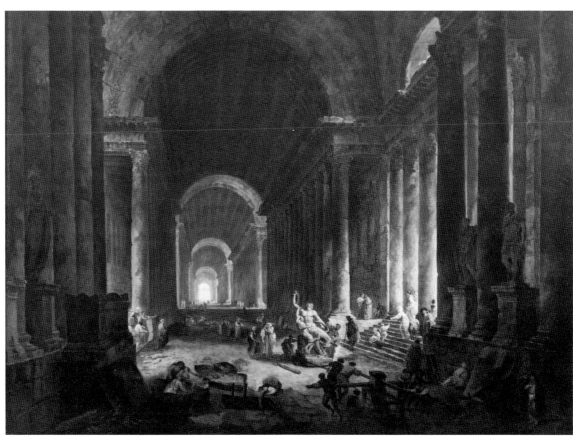

inventions. This is clearly seen in his undated *Caprice View of Ancient Roman Monuments* (fig. 8); in this example of topographical caprice, antique architectural and sculptural monuments of Rome (several of which also appear in the Méréville pictures) are combined and juxtaposed without regard to their actual proximity or relative scale. Robert's spirit of freewheeling yet informed historicism, so evident here, was also operative in his conception of the Méréville caprices. In these works, executed over twenty years after his return to France from Rome, a number of Roman monuments are imaginatively recombined, reinterpreted, and recontextualized. For example, in *The Landing Place*, one of the *Monte Cavallo Horsetamers* from the Quirinale surmounts a very "Piranesian" architectural form consisting of intersecting arched colonnades, while in the foreground a statue of Juno (based on an ancient model) overlooks a stepped landing place reminiscent of the Roman Porta di Ripetta. In another work, *The Fountains*, two statues modeled on the *Dioscuri* from the Campidoglio stand above two sarcophagi (realistically put to use as public fountains) and flank a stairway leading to a series of generic Roman triumphal arches connected by a colonnade that could have been inspired by a number of Roman monuments, among them the Baths of Caracalla and Bernini's Colonnade at St. Peter's. Both works, like the other two in the series, are distinguished, in their connections with Rome, by an equivalency of erudite reference and sophisticated fantasy and, moreover, all bear witness to the durability of Robert's Roman recollections.

Robert's conversance with classical antiquity served him equally well in the role of chief garden designer at Méréville. Like many cognoscenti of his time, the Marquis de Laborde was swept up in the vogue for the antique that had an enormous impact on artistic production in the Age of the Enlightenment. He intended his garden to make erudite references to the classical past (among other historical periods) and, accordingly, Robert's design includes a number of strategically placed *fabriques* (garden structures) of classical inspiration, among them a triumphal column and a temple of love modeled respectively after Trajan's Column in Rome and the famed Temple of the Sibyl at Tivoli. The spectacle of a perfectly intact Roman temple sitting atop a craggy hillside in a romantic landscape with a turreted chateau in the distance, as seen in a view of the garden (fig. 9) by Robert, is somewhat strange to modern eyes, but it is nevertheless perfectly consistent with eighteenth-century taste. The park at Méréville, like many gardens built at the same time, was conceived as a "land of illusions" comprising a series of coherently planned and cleverly crafted tableaus exhibiting a delicate balance, in regard to geographical context and historical reference, of fact and fantasy.[9] Thus, it can be maintained that there is, at least in a broad sense, a formal and conceptual parallel between the garden and the architectural caprices (this will be discussed in detail at a later point in this essay).

The first step toward a thorough comprehension of form and meaning in these pictures is to consider Robert's sources and influences. It should be noted that they pay direct homage to four Italian (and predominantly Roman) traditions of architectural representation: *veduta ideale*, *veduta di fantasia*, *prospettiva*, and *rovinismo*. *Veduta ideale* took the form of paintings and drawings, usually executed for the tourist trade, depicting actual (and usually famous) structures capriciously arranged (such as Robert's literal quotations from Roman antiquity in the Méréville pictures). *Veduta di fantasia*, on the other hand, consisted of representations of entirely (or almost entirely) fictive structures and cityscapes. Robert is the most famous artist from the rather large school of French *veduta di fantasia* painters and draftsmen which includes lesser-known figures like Charles Michel Ange Challe, Jean Charles Delafosse, Louis Joseph Lellorain, and Jacques Henri Alexandre Pernet. These artists catered to a sizable market for architectural and/or ruin fantasy, and all were greatly influenced by Piranesi's speculative visual re-creations of Roman architecture (see fig. 15).[10] Robert executed a considerable number of "Piranesian" topographical caprices, such as his *Majestic Bridge and Palace* (fig. 10), distinguished by his imaginative juxtaposition and combination of grandiose architectural elements. The paintings for Méréville can, likewise, be categorized as French interpretations of Piranesi's imaginary views. By virtue of their form and function, they can also be directly linked to *prospettiva* (the roots of which can be traced as far back as Pompeiian wall painting), a decorative mode concerned largely with the creation of illusionistic architectural perspectives and urban views for interiors and theatrical backdrops; these works have theatrical qualities that evoke the spirit of Baroque stage sets, with their endless arcades and colonnades. However, the Méréville paintings' closest connection is with *rovinismo*, which encompassed all types of ruin depictions including views (*vedute*) of actual ruins and ruin caprices (*caprizzi*).

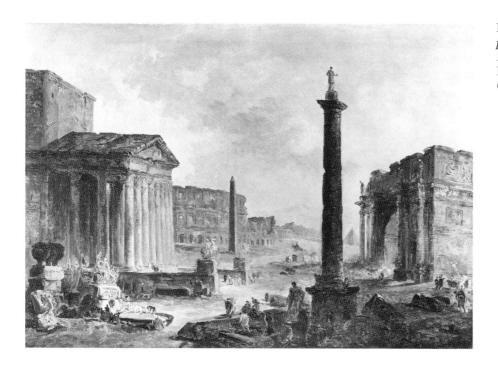

FIGURE 8. Hubert Robert. *Caprice View of Ancient Roman Monuments*, n.d. Oil on canvas. Bourges, Musée du Berry. Photo: Giraudon.

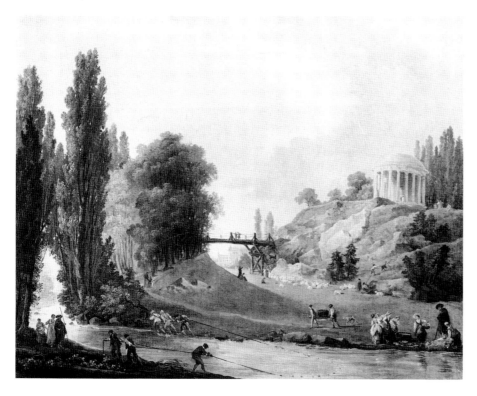

FIGURE 9. Hubert Robert. *View of the Park at Méréville*, c. 1787. Oil on canvas. Paris, Collection of H. Roger Viollet. Like many gardens of the time, the park at Méréville mingled architectural fantasies, such as this Roman temple and turreted chateau, to create a "land of illusions." As the designer of this park, Robert exemplified the multitalented artist common in the eighteenth century.

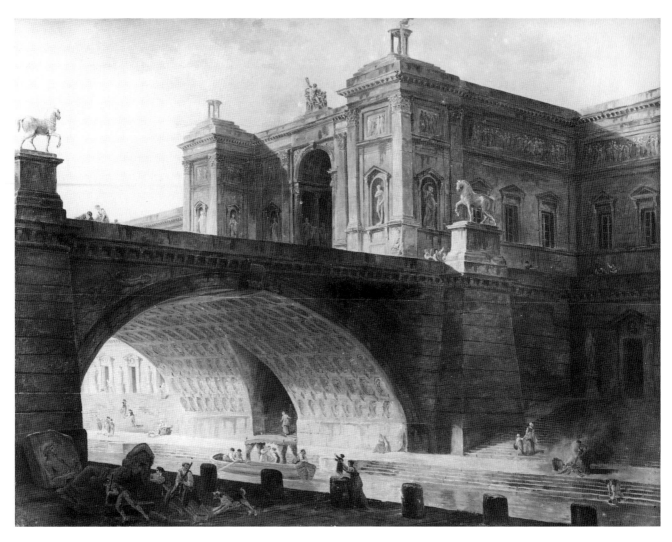

FIGURE 10. Hubert Robert. *Majestic Bridge and Palace*, n.d. Oil on canvas. Boston, Murray Collection. Photo: Bulloz.

As late as the first decades of the eighteenth century, there was little in French art to match the intense interest of Italian artists in *rovinismo*. This situation gradually changed as a result of the exposure of French artists to the treasure trove of inspiring ruin motifs in Italy and to the works of Italian ruin painters like Giovanni Ghisolfi (c. 1623–1683), Marco Ricci (1676–1729), and, most importantly, Giovanni Paolo Pannini (1691–1765). Pannini, an Italian master of all four modes of architectural representation mentioned above as well as pure topographical

view (*veduta*) painting, was the artist who exerted the most profound influence upon Robert during his formative years.[11] He was Robert's mentor and it was in imitation of Pannini that he decided to become a painter of architecture and ruins. The extent of Robert's debt to Pannini is indicated by an entry in the catalogue of the posthumous sale of Robert's collection which states, "this group of twenty-five paintings by the hand of Pannini . . . was considered by Hubert Robert as the treasure of his studies, repeating daily that he owed to them, after Nature, the greatest part of his success."[12] By the 1780s (indeed by the mid-1760s), Robert had outgrown his tendency to slavishly imitate Pannini but, as a comparison of *The Fountains* and *The Landing Place* with

Pannini's *Antique Ruins with Scene of Apostle Preaching* (fig. 11) will indicate, the latter's influence was enduring. Among the numerous derivations from Pannini evinced by the Méréville pictures, the most obvious are the horizontal arrangement of the ruins across the entire width of the picture plane, the view into the distance through the ruins, and the shallow, stagelike foreground space. All are recognizable holdovers from the northern Italian tradition of theatrical decoration; indeed, *The Fountains* and *The Landing Place* look very much like the illusionistic architectural fantasies used in the eighteenth century as backdrops for plays, operas, and ballets set in antiquity. They also repeat Pannini's choice and treatment of ruin motifs, specifically his arched colonnades and stairways with the jagged silhouette of a ruined arch set against the sky. In addition to these pointed references, there is a similarity of "ethos"—rustic and togate staffage (serving primarily to "staff" the picture rather than answering a dramatic or narrative purpose) figures occupy the foregrounds of the Méréville pictures as they do in the Pannini work. Some gesture toward or contemplate the ruins, some lean or sit upon ruin fragments, and some simply go about their business. The naturalistic sense of the interraction of people and ruins evident in all these paintings was an outgrowth of the artist's familiarity with the Roman scene where ruins are a setting for everyday life.

The Italian origins of the Méréville caprices are undeniable, but their connections with French traditions should also be recognized. The evolution of French ruin painting must inevitably be measured against the career of Hubert Robert, since the genre reached its height at the time that Robert was producing his most accomplished works (around 1765 to 1785). But, by the time that Robert returned to Paris from Rome in 1765, ruin painting had been practiced by French artists for over a century (more precisely, ruins are frequently seen in heroic and pastoral landscapes dating from this period). To a certain extent, Robert's achievement was prefigured by seventeenth-century painters such as Jean Lemaire (1598–1659), whose works evince a taste for fictive ruins that took hold so strongly in the eighteenth century.[13] Lemaire's works foreshadow Robert's ruin paintings in several important respects: works like his *Ancient Monuments* (fig. 12), executed around 1640, are among the earliest pure ruin caprices to be painted by a French artist. There is no discernible biblical, mythological, or historical pretext for the inclusion of the ruins and, correspondingly, the figures serve only to animate the scene. It can therefore be said that the ruins themselves are the subject of the pic-

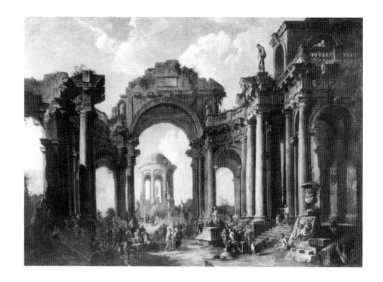

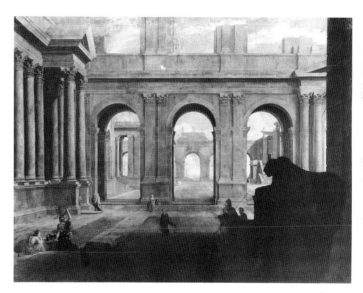

TOP

FIGURE 11. Giovanni Paolo Pannini (Italian, 1691–1765). *Antique Ruins with Scene of Apostle Preaching*, c. 1725. Oil on canvas. Paris, Musée du Louvre. Photo: Réunion des Musées Nationaux. The ruin paintings of this Italian artist exerted a profound influence on Robert.

BOTTOM

FIGURE 12. Jean Lemaire (French, 1598–1659). *Ancient Monuments*, c. 1640. Oil on canvas; 147 × 198 cm. Paris, Musée du Louvre. Photo: Réunion des Musées Nationaux. Lemaire was a seventeenth-century painter of fictive ruins whose work prefigures that of later French artists such as Robert.

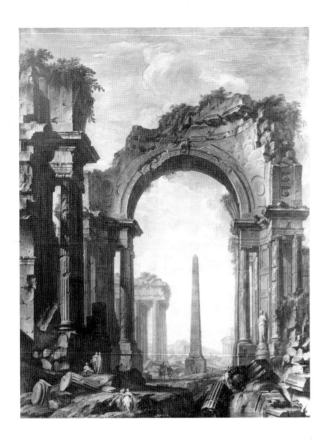

FIGURE 13. Giovanni Niccolò Servandoni (Italian, act. France, 1695–1766). *Ruins of the Ionic Order*, 1731. Oil on canvas; 259 × 195 cm. Paris, Ecole des Beaux-Arts. Photo: Réunion des Musées Nationaux. Servandoni's presentation piece to the Académie royale de peinture et de sculpture features diminutive figures overwhelmed by the dramatic scale of the ruins around them.

ture; it is equally significant that they were based on Lemaire's first-hand knowledge of Roman architecture. He was a precocious student of Roman antiquity and, as William Barcham has painted out, "Lemaire was the painterly architect whose task it was to render pictorially the glory of ancient Rome."[14] Before we call Lemaire a seventeenth-century "Hubert Robert *avant-la lettre*," however, we must take note of the manner of execution of his ruins which are stiffly drawn and seem fixed in time. He was, like all seventeenth-century painters of ruins, largely oblivious to the connotations of decay and mortality that came to the forefront with the romantic perception of ruins in the eighteenth century. In an era in which there was nothing to compare with the writings of Edward Gibbon or the Comte de Volney, ruins were seen as the enduring symbol of ancient imperial magnificence. As Robert Rosenblum has indicated, Hubert Robert's response to ruins was different: he shared the attitude of his contemporaries Gibbon and Piranesi before ruins. All three viewed these remnants of an antique past as "an organic metaphor, a civilization that has lived and died and is now left to be devoured by time and nature."[15]

The change of attitude apparent in Robert's ruin pictures, where the ruins have become the focus of intense interest and the vehicle for meditation on the cyclical processes of history, was anticipated by two of his forbears, Giovanni Niccolò Servandoni (1695–1766) and Pierre Antoine de Machy (1723–1807).[16] Servandoni, who probably studied with Pannini, played an especially

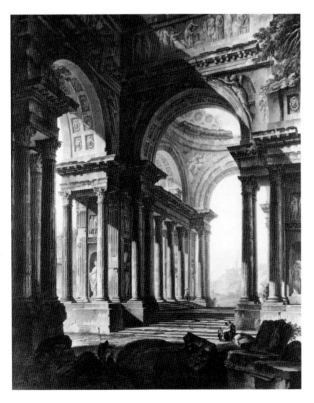

FIGURE 14. Pierre Antoine de Machy (French, 1723–1807). *Temple in Ruins*, 1757. Oil on canvas; 161 × 129 cm. Paris, Musée du Louvre. Photo: Giraudon. In this painting, the ruins are treated like contemporary theatrical decoration; like them, offering a view through the arches to the buildings and columns in the distance.

pivotal role in the evolution of French ruin painting away from the lifeless creations of most seventeenth-century practitioners toward the suggestive and emotionally charged works of Robert and his generation of ruin specialists. Servandoni came to Paris from Italy in 1724; in 1731, he was received into the Académie royale de peinture et sculpture as "Peintre dans le talent de l'Architecture et de la Perspective" (painter of architecture and perspective views).[17] As his presentation piece, he submitted a large work, *Ruins of the Ionic Order* (fig. 13), in which we see a ruined archway resting on ionic columns. In the distance, and almost at the center of the arch, there is an obelisk and, behind it, ruins of another structure. The foreground is occupied by a statue of a female figure, architectural fragments, and figures in pseudo-antique and rustic dress. This combination of features bears witness to Servandoni's wholesale borrowing from Pannini and also suggests very strongly that pictures by Robert such as *The Obelisk* and *The Fountains* are in a direct line of descent from *Ruins of the Ionic Order*. There is an obvious similarity in the choice of motifs, among them the obelisk at the center of an arch, but an even more significant, and forward-looking, feature of Servandoni's picture is the dramatic scale of the ruins, conveyed in part by the relatively insignificant scale of the staffage figures. Furthermore, Servandoni, like Robert after him, located the viewer close to (one could even say within) the ruins and he likewise employed an elongated vertical format to emphasize their great height. Before Servandoni came to France, comparable ruin fantasies had been put to use in that country only as theatrical decoration. He also was a master of *prospettiva*, and his ties to that tradition are quite apparent in *Ruins of the Ionic Order*, but this work in addition signals his transcendance of the conventional decorative application of ruin caprice which he brought into the realm of large-scale academic painting.

In academic ruin painting, Servandoni set a standard of grandeur and grandiloquence that surpassed Pannini's achievement; he became a model for a later generation of French *ruinistes* (ruin painters) seeking official approbation. One of these was his student Pierre Antoine de Machy. In de Machy's reception piece for the Académie, his *Temple in Ruins* (fig. 14) of 1757, the repertoire and treatment of the architectural forms is directly comparable to Servandoni's; columns support arches, pendentives, and part of a dome that has fallen in; blocks of stone, capitals, etc., lie scattered in the foreground and the inclusion of the growth of plants atop the ruins is quite

similar, as is the diminutive size of the figures relative to the architectural setting.[18] Another similarity is the treatment of the ruins like theatrical decoration, even to the extent of retaining a view through the arches with another building and a commemorative column (here substituting for Servandoni's obelisk) acting as a focal point in the distance. Despite de Machy's liberal borrowings from Servandoni, however, he must be given credit for originality. His architectural and sculptural forms are both generic and composite types based on sources as diverse as triumphal arches, the Basilica of Maxentius, and the Forum of Nerva. Unlike Servandoni, he included above the arch at the center of the picture a literal quotation from classical antiquity: the relief frieze of the *Punishment of Arachne* from the Nerva forum. This indicates that the *Temple in Ruins* is a transitional work that anticipates the increased sophistication, vis-à-vis classical antiquity, of a younger generation of ruin painters like Robert.

De Machy made a significant contribution to the evolution of French ruin painting. In terms of its style and imagery, his *Temple in Ruins* is only slightly less advanced than Robert's *The Obelisk* which it closely resembles and which was executed thirty years later. De Machy broke new ground by picking up where Servandoni left off and aggressively subverting the decorative role of ruin caprice. His *Temple in Ruins* evinces a new fascination with the sublimity of ancient architecture; he placed the viewer even closer to the ruins, which are more imposing and, hence, less decorative than Servandoni's; and he conveyed a sense of their oppressive mass more forcefully through his use of dramatic angular perspectives and very strong contrasts of light and shadow. All these stylistic devices, which also serve to augment the emotive and expressive effect of the ruin motifs, were derived from the prints of Piranesi who, in turn, was primarily interested in the promulgation of his megalomaniacal vision of the magnificence of ancient Rome. The influence upon de Machy of works such as his *Porticos Around a Forum* (fig. 15), from the *Opere varie*, is immediately apparent when it is compared with the *Temple in Ruins*, a very early example in French art of the adaptation of the idiom of Piranesi's prints to architectural painting for the purpose of evoking the sublimity of Roman ruins.

Of all the sources and influences conflated in Robert's Méréville pictures, his adaptation of Piranesi's grandiloquent vision of antiquity had the most pronounced effect. It is this, above all, that lifts the four works out of the

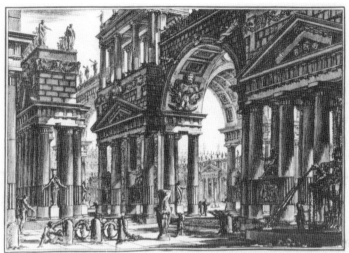

Portici tirati dintorno ad un Foro con palazzo regio

FIGURE 15. Giovanni Battista Piranesi (Italian, 1720–1778). *Porticos Around a Forum* from *Opere varie di architecture, prospettive, grotteschi, antichitá,* published 1750. Etching. Photo: Miranda Harvey, *Piranesi, The Imaginary Views* (New York, 1979), p. 67.

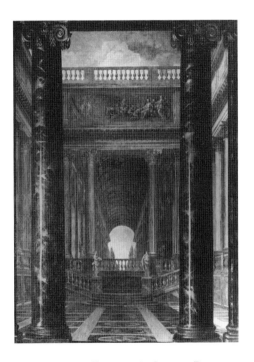

FIGURE 16. Jacques Rousseau (French, 1630–1693). *Trompe l'Oeil Architectural Painting,* n.d. Oil on canvas. Versailles, Musée du Château. Photo: Réunion des Musées Nationaux.

realm of decorative painting, even though they are all part of an ostensibly decorative program. In conformity with eighteenth-century notions of the sublime, as conceived by the philosopher Edmund Burke and concretized by Piranesi, Robert's colossal ruins convey a sensation of primitive *terribilità*. They give visual form to Burke's ideas as put forth in his monumental essay *A Philosphical Enquiry into the Origin of Our Ideas of the Sublime and Beautiful* (1756), in which he stated that the physical characteristics that contribute to an evocation of the sublime are great size, ruggedness, irregularity of form, and dramatic contrasts of light and dark. Robert intended the viewer of these ruined structures to stand in awe of their terrifying mass and to be deeply moved by their suggestion of the demise of imperial magnificence. This approach is in stark contrast to the conventionally decorative application of architectural pictures executed as a group for placement in a domestic interior setting. A good example of this latter type is a seventeenth-century trompe-l'oeil painting (fig. 16) by Jacques Rousseau (1630–1693), one of a pair in the Salon de Vénus at Versailles.[19] Rousseau employed techniques borrowed from Italian *prospettiva* (such as the convincing marbleizing of the columns) to create a believable illusion of depth and of the flow of space from interior to exterior. The architectural elements are used only as illusionistic devices serving primarily as points of demarcation for the receding planes. By contrast, Robert's architectural forms, which also serve to expand the interior space, are anything but innocuous. They were meant to dominate the room they were placed in and to be disquieting and thought-provoking, rather than being simply part of the overall scheme of interior decoration.

Robert's forceful reaction against the decorative role of architectural painting is equally apparent in his other series of ruin paintings. Interestingly, Robert executed another series of four large, and ostensibly decorative, pictures immediately before starting work on the paintings for Méréville. In 1786, he was ordered by the Comte d'Angiviller, Superintendant of the Royal Buildings, to

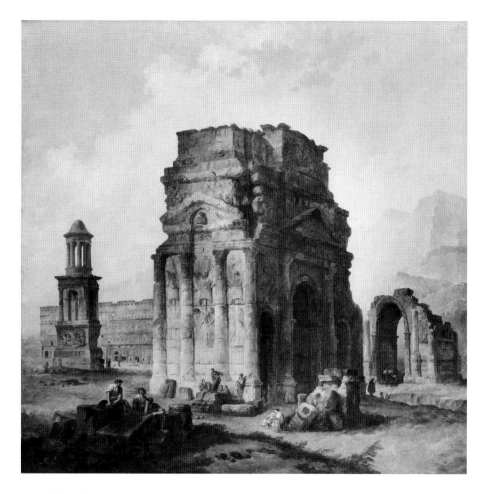

FIGURE 17. Hubert Robert. *The Triumphal Arch and Amphitheater at Orange and the Monument and Small Arch at Saint Rémy*, 1787. Oil on canvas; 242 × 242 cm. Paris, Musée du Louvre. Photo: Giraudon.

paint four large pictures of the Roman monuments of Provence for the king's dining room at Fontainebleau.[20] The pictures (now in the Musée du Louvre, Paris) were exhibited at the Salon of 1787, and it is possible that the Marquis de Laborde's admiration for them led him to commission the series for his chateau in that same year.[21] They are Robert's supreme achievement as a *ruiniste*, as well as his most aggressive assertion of his grand manner of Neoclassical ruin painting. In one of the Fontainebleau works, *The Triumphal Arch and Amphitheater at Orange and the Monument and Small Arch at Saint Rémy* (fig. 17), Robert, through the boldness of his treatment of the ruin motifs, conveyed his great enthusiasm for archeological discovery as well as the nationalistic pride associated with the celebration of France's rich treasure of classical architecture.[22] His use of a new and indigenous iconography, the antique monuments of France, is a point of departure from the customary dependence of French painters on Italian architectural imagery; his approach to the *veduta ideale* is equally fresh. With its arbitrary grouping of ancient monuments, *The Triumphal Arch and Amphitheater at Orange and the Monument and*

Small Arch at Saint Rémy is, in the generic sense, a "Pannini-esque" *veduta ideale*, but Robert's intense concentration on the central architectural motif, which takes up a large part of the foreground space in the expansive canvas and which conveys an impression of massiveness and geometric severity, is completely foreign to the pictorial world of Pannini. It was Robert's intention to achieve a sublime effect through an exaggeration of the scale and prominence of the individual structures. The triumphal arch, in a manner reminiscent of Piranesi's treatment of Roman triumphal arches, is made to look both immense and mysterious through the use of dramatic chiaroscuro lighting and the inclusion of tiny figures. Here the ruin has become an object of contemplation in its own right and a means of eliciting a powerful emotional response.

Robert's goals were the same in his Fontainebleau series and in the works for Méréville. These paintings are distinguished by a distinctively "French" combination of diverse Italian influences (foremost among them Piranesi and Pannini) and by Robert's aspiration to attain in ruin painting a level of grandeur and emotive power equaling

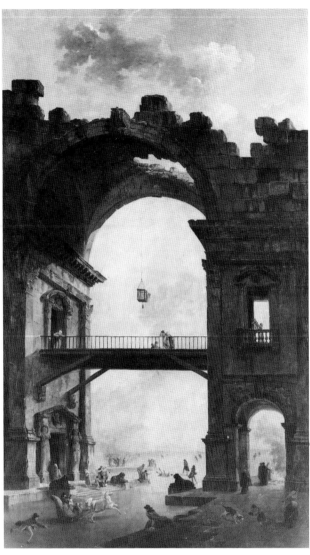

FIGURE 18. Hubert Robert. *Ruin Caprice (Winter)*, n.d. Oil on canvas. Avignon, Musée Calvet.

very much like the Méréville group. All the pictures (see fig. 18) are allegories of the four seasons; Robert, typically, drew a parallel between the cycles of nature and those of human history and culture as symbolized by the ruins. What then is the core idea that ties together the individual works in the Méréville series? One likely possibility is that they are all symbolic portraits of the garden. Robert was intimately familiar with the garden's symbolic elements and it is not surprising that this would be reflected in his choice of imagery for the paintings and in their disposition: the four works can be divided into two groups; two paintings, *The Ancient Temple* and *The Obelisk*, convey a feeling of somberness and oppressiveness with their massive shadowy forms occupying most of the pictorial space, whereas in *The Fountains* and *The Landing Place*, the architecture is lighter and more transparent and there is a degree of airiness. One likely reason for this difference is that it is a reflection of the dual nature of the garden complex which was meant to inspire profoundly melancholy sentiments while simultaneously functioning as a place for amusement and refreshment. The validity of this interpretation is underscored by a consideration of parallels between the picture's principal themes and the elements that comprise the garden. *The Ancient Temple* and *The Obelisk*, with their connotations of mortality and commemoration, correspond to elegiac and memorial elements, among them an artificial ruin of a Roman temple, a Tomb of Captain Cook, and a Rostral Column dedicated to the memory of the Marquis de Laborde's sons who perished on the ill-fated La Pérouse expedition of 1785–88.[23] The other two paintings, *The Landing Place* and *The Fountains*, are reminders of the elaborate aquatic artifice (including artificial lakes, streams, and cascades) that is the distinguishing feature of the gardens at Méréville.

That Robert's ruin paintings are thematically and conceptually linked to the garden complex is not surprising. We should also be aware of their universal significance, in relation to the cult of ruins, that transcends their specific contextual meaning. A consideration of a work that is not in the Méréville series will serve to introduce a discussion of the deeper sense of Robert's works and the way they were perceived by his contemporaries. The elongated

that of history painting. The questions that remain to be answered are what motivated the choice of particular themes and images in the four paintings for the small salon at Méréville and in what specific way, if any, did they relate to the overall conception of the garden? The visual evidence, as well as what we know of Robert's artistic intentions, suggests very strongly that the choice was anything but haphazard and that, in fact, the paintings and the garden are both aspects of a coherent scheme. It has already been shown that Robert executed another series of four paintings in which there is a discernible unifying theme (the grandeur of the antique monuments of Provence). There is, in addition, a series presently conserved at the Musée Calvet in Avignon which looks

format of his painting *The See Saw* (fig. 19) of 1786 and the pleasant feeling it initially conveys suggest that it was meant only to be part of a scheme of interior decoration. However, a more searching examination reveals that it is in actuality a melancholy and thought-provoking work in which there is much subtlety and complexity. Robert arbitrarily removed the Temple of Vesta from its lofty setting overlooking the Grotto of Neptune at Tivoli; it no longer dominates its surroundings but, rather, is being reintegrated with nature: column fragments are strewn about like rocks, and other debris and the jagged and pitted stones are invaded by plants. Robert's transplantation of such a famous (and venerable) edifice into this new and less exalted setting strikes a discordant note, as does his inclusion of the cavorting peasants; their humble presence is at odds with the crumbling, yet still imposing, remnant of a formerly magnificent civilization. Robert also exploited the irony of the transformation of a pagan temple into a rustic dwelling complete with a flower pot and bird cage in one of the openings of the cella, a crude wooden balustrade inserted between the columns, and hanging laundry. The depiction of such a renowned edifice being used for the most mundane purposes was meant to inspire melancholy sentiments and to produce a heightened awareness of the fragility and impermanence of architecture and, by inference, of human life.[24] This message is driven home by the game of see saw, a touching reminder of the rise and fall of the fortunes of men.

The didactic and expressive ends of the Méréville pictures are essentially the same as those of *The See Saw*: they were meant to stimulate metaphysical speculation on the elemental truths of history and human existence. The major difference between them is that the wistful emotions and delicate sentiments of *The See Saw* have yielded to powerful emotions and grand thoughts in the Méréville caprices. In this regard, they tie in neatly with literary aspects of the cult of ruins. The emotional responses of writers such as Diderot and the Comte de Volney to ruins, both real and painted, are the best indications we have of the full range and profundity of meaning and implication in Robert's ruin pictures. They also help us to locate Robert's images in their cultural context. The

Comte de Volney's *Ruines, ou méditations sur les révolutions des empires* (1791) is particularly illuminating in this regard. In this book, the subjective reactions of a traveler to the ruins of the ancient city of Palmyra are recounted as a train of thought:

> This lonely place, this calm night, this majestic scene bring out a religious feeling in me. The sight of a great deserted city, the memory of time gone by, the comparison with the present, all lift my heart to great thoughts. . . . And now look what remains of a vast dominion . . . a wretched skeleton, what remains of this powerful city . . . an obscure memory. Thus perishes the work of men, thus empires and nations vanish.[25]

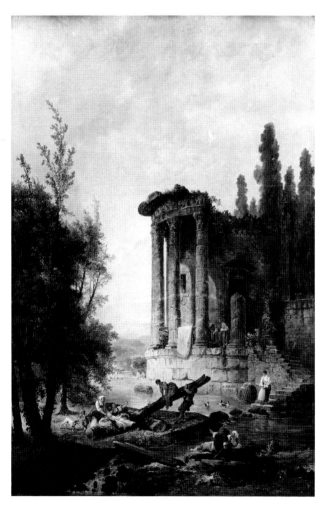

FIGURE 19. Hubert Robert. *The See Saw*, 1786. Oil on canvas. Wildenstein Collection. Photo: Bulloz.

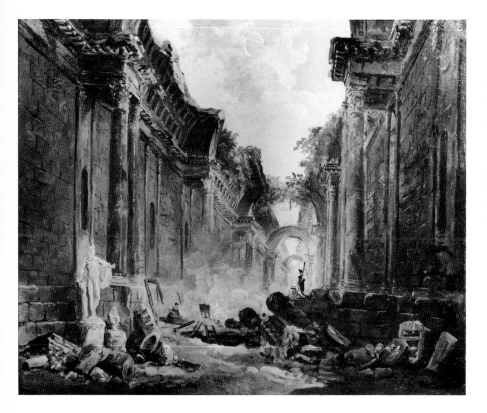

The intense emotionalism evident in this passage is typical of the romantic attitude in general toward ruins. This was articulated in an even more intense way by the French encyclopedist and philosopher Denis Diderot (1713–1784), the most eloquent literary voice of the cult of ruins:

> The ideas that ruins awake in me are grand. Everything vanishes, everything dies, only time endures. How old this world is! I walk between two eternities. Whichever side I look to, the objects that surround me announce the end. What is my ephemeral existence compared to that of a rock that crumbles. I see the marble of tombstones fall into dust and I do not wish to die! . . . A torrent carries along one nation after another to the bottom of a common abyss; I alone aspire to cling to the shore and resist the tide. . . . [26]

This moving passage from Diderot's discussion of Robert's *Grand Gallery Illuminated from Behind* (which was similar in style and subject to *The Ancient Temple*) in his commentary on the Salon of 1767 bears witness to the emotive, inspirational, and cathartic effect on contempo-rary observers of Robert's painted ruins. For Diderot, ruins produced an awareness of man's frailty and isolation when confronted by the ineluctable flight of time. He also considered ruins to be metaphors for his own mortality. To a certain extent, Robert's works engendered such a passionate emotional and philosophical response because of his masterful evocation of the sublimity of Roman ruins. More importantly, the factors that were the cause of Diderot's great admiration for Robert were essentially the same as those that led him to laud the still-life painter Jean Baptiste Siméon Chardin (1699–1779) and the painter of scenes of everyday life Jean Baptiste Greuze (1725–1805). For Diderot, these artists were moral exemplars because of their close observation of, and truth to, nature, and because one could derive moral instruction from their works. Robert's ruin pictures also conform to Diderot's doctrine of a "peinture morale" (moral painting); his expression of elemental truths was, in terms of Diderot's ideology, a virtuous act not unlike Greuze's celebration of basic bourgeois values. For both Diderot and Robert, ruined structures were more morally charged and revelatory than intact ones, because they offered eloquent testimony to the existence of architecture (a concrete manifestation of material and artistic culture)

within the continuum of time and history. The "vraie nature" (true nature) of architecture could be revealed only through the actual passage of time or through the painter's ability to suggest the ongoing process of decay and degradation. Diderot made his position clear in a passage written in 1763:

> I believe that great ruins are moving in a way that intact structures are not The hand of time has sown, amidst the moss that covers them, a host of great ideas and melancholy sentiments. . . . I ponder the people who produced such marvels and who are no longer with us.[27]

For Diderot and Robert, the implications of ruins were both personal and cultural. The conclusion, borne out by the ever-present example of classical antiquity, that the demise of all societies is inevitable, led directly to thoughts of personal mortality—man and society subject to the same immutable laws of nature. Robert's most stirring exploration of this idea can be found in his depiction of *The Grand Gallery of the Louvre Imagined in Ruins* (fig. 20) of 1786.[28] In this picture, the Grand Gallery (which in the years from 1795 to 1801 was being remodeled for use as a picture gallery) is seen as it might look in ruins at some distant future time. The fashionable gallery visitors who are depicted in the pendant to this painting, *Project for the Remodeling of the Grand Gallery of the Louvre* (Paris, Musée du Louvre), have been replaced, as in all of Robert's depictions of ruined antique galleries, by common types who seem to inhabit the ruins. Gone as well are the paintings and sculptures and the innovative skylights that illuminated them and, in a manner reminiscent of *The Ancient Temple* from the Méréville series, the great coffered vault has fallen in and the exposed edges are overgrown with plants. Curiously, the statue of the *Apollo Belvedere* stands amidst the wreckage as if to convey the bittersweet and ironic message that art and beauty will endure the ravages of time while the majestic structures built to contain the objects will not. There are shades of meaning in this picture that do not fall within the scope of this study, but it is clear that Robert meant to apply the lessons learned from the past to the present and the future—Paris with all its pretentions to glory must inevitably go the way of imperial Rome and become a shattered vestige of its former self.[29] *The Grand Gallery of the Louvre Imagined in Ruins*

exudes the spirit of universal fatalism that pervades Robert's art and gives it its moral force.

It was this quality, rather than his mastery of a certain range of subject matter, that made Robert a natural choice to paint pictures for the interior of the chateau at Méréville. Enlightened patrons like the Marquis de Laborde commissioned Robert's ruin pictures for much the same reason that they erected artificial ruins in their gardens. For the visitor to the park at Méréville who was possessed of even moderately developed sensibilities, the jagged silhouette and crumbling walls of the Ruined Temple would offer a sobering reminder of the passage of time and the inescapability of death in contrast to the frivolous delight of the grottos and cascades. Robert, the designer of the Ruined Temple, was also instrumental in creating the atmosphere of an Elysium, a place "made for melancholy," in certain areas of the garden.[30] If the Rostral Column and the Tomb of Captain Cook (also designed by Robert) could bring forth sentimental meditations on departed heroes and family members in an idyllic pastoral setting, then the small salon, with its four stately ruin paintings, was the place to ponder the grander implications of mortality. Ruins, a traditional symbol of mortality (*memento mori*), were put to use as reminders of the inevitable demise of all things, including civilizations. Robert's antique ruins are a universal symbol that is the perfect counterpart to the pointed elegiac references made by the (classically derived) memorial structures in the park. The four ruin caprices are, therefore, an integral part of the overall conception of the garden complex, one that encompasses a range of attitudes and expressions from sentimentalism to the sublime.

They are also works that signal Robert's transcendance of ruin painting's "lowly" academic status. Robert stands at the apex of the evolutionary pyramid of French ruin painting; as the heir to a varied range of influences, he arrived at a unique synthesis of style and content and greatly expanded the symbolic and emotive range of his genre. Like his contemporary, the French painter of historical subjects Jacques Louis David (1748–1825), he was in the Neoclassical vanguard in the 1780s, using the classical past as a rich source of subject matter, as a model of grandeur in form and expression, and as the foundation for high-minded moralizing and didacticism. The Méréville pictures show Robert at the height of his powers, which is to say that they show French ruin painting in its most sublime form.

Antonio Canova and Quatremère de Quincy: The Gift of Friendship

IAN WARDROPPER, *Associate Curator, European Decorative Arts, Sculpture, and Classical Art; and* THOMAS F. ROWLANDS, *University of Illinois at Chicago*

T he *Bust of Paris* (figs. 1–2) is the first major work by the preeminent Neoclassical sculptor Antonio Canova (1756–1822; see fig. 3) to enter the collection of The Art Institute of Chicago.[1] Its dedication (fig. 5), ANT.NIO QUATREMERE/AMICO. OPTIMO/ANTONIUS. CANOVA/DONO DEDIT/F. ROMAE/AN.MDCCCIX (To Antoine Quatremère, best of friends, Antonio Canova dedicates this gift, m[ade] in Rome, 1809) bears witness to the remarkable friendship between the bust's maker and its recipient, the critic and theorist Antoine Quatremère de Quincy (1755–1849; fig. 4). As an important and much-discussed marble chiseled by Canova, the recently rediscovered bust helps to clarify aspects of his style and working methods. Even more interesting, however, is the light it sheds on the relationship between two men who were arguably the greatest artist and the most influential critic of the Neoclassical movement. As the subject of many letters exchanged between them, the bust reveals their common artistic aims, as well as the far-reaching influence the critic held over the sculptor.

The bust represents Paris turning his head to gaze in judgment of the beauty of the three goddesses Juno, Athena, and Venus. Unconscious of the moment's gravity—that his choice ultimately would lead to the disastrous Trojan Wars—a smile flickers across his smooth, idealized features. This is an image of innocence and nostalgia, since Paris's simple state as a shepherd living on the slopes of Mount Ida will disappear once his decision is made. From the moment he is rewarded with the most beautiful mortal woman, Helen, Paris

FIGURE 1. Antonio Canova (Italian, 1756–1822). *Bust of Paris*, 1809. Marble; h. 70 cm. The Art Institute of Chicago, Harold Stuart Fund; Mrs. Harold T. Martin Restricted Gift (1984.530). This work, which Canova dedicated to his friend the art critic Quatrèmere de Quincy, represents the shepherd Paris at the moment he judges the beauty of the three goddesses Juno, Athena, and Venus.

39

abandons his idyllic tranquility for the hectic world of politics and war. Paris himself represents ideal beauty, as he was reputed to be the handsomest mortal man. He was also a connoisseur of beauty, and thus an appropriate subject to give to an art critic.

Canova's formal treatment of the bust is sensitive. In contrast to the simplicity of Paris's face and the volumetric clarity of the phrygian cap—which associates him with the region of present-day Turkey, where he lived—a mass of curly locks plays across his temples and dangles down his neck. The chest is severely truncated but in a parabolic curve that rhymes with the shape of the hat. That Paris is depicted in the moment of judgment is not self-evident; only by comparing the bust to the full-length statue that Canova began shortly before carving the bust is this context revealed (see fig. 6). The plaster model for the over-life-sized statue was begun before December 1807, while the marble based on it was commissioned by Empress Josephine in 1808. Paris leans on a tree trunk; his left hand grazes his head, his right clutches the golden apple of the Hesperides, the winner's prize which he would award to Venus. For the bust, Canova retained the sharp twist of the head, emphasizing the act of looking; the hand-to-head gesture, which reinforced the hero's mental activity, had to be omitted. Seeing the head divorced from the pose and props of the full-length composition forces the viewer to focus on the pure beauty of Paris himself, reversing attention from judged to judge. The object of Paris's gaze becomes less important than the intelligence and spirit behind the expression.

The full-length statue and bust were so popular that copies of both were made by Canova or his workshop. Sorting out the status of these various works and specifying the relationship of bust to statue are necessary in order to clarify Canova's working methods and attitudes toward the sculptural process, and to explain the significance of the bust that Canova carved for Quatremère, which is now in the Art Institute's collection. Documents indicate that Canova made four full-length marble statues as well as several busts of Paris. Today the four statues are accounted for, while at least seven busts are known. The first full-length statue was begun in 1808 and finished in 1812; it graced Josephine's villa at Malmaison and, after her death, was sold to Czar Alexander I of Russia, finally entering the Hermitage Museum in Leningrad. The second full-length statue was begun in 1810 on commission for Prince Ludwig of Bavaria and finished in 1816; it is now in the Neue Pinakothek, Munich. Furthermore, two statues of Paris, which may or may not have been finished, were recorded in Canova's studio at his death. One of these is in the museum at Asolo, Italy; the other is apparently identical with one formerly in the collection of Lord Londonderry but sold in 1962.[2]

Of the busts, two were recorded as gifts from Canova, one for Quatremère de Quincy in 1809 and another for Monsieur Alquier, the French ambassador in Rome, of uncertain date, though possibly earlier than the former.[3] Today busts of Paris are known in the Hermitage and Neue Pinakothek, where they accompany the full-length statues; one in the Ny Carlsberg Glypthothek, Copenhagen, with a provenance from the French statesman Charles Maurice de Talleyrand, Prince de Bénévent; two in Rome, in the Museo Pio Clementino at the Vatican and in the Museo Nazionale; a copy in the Nationalgalerie

of East Berlin; and the one now in Chicago.[4] The association of busts with statues has led to the assumption that both the full-length and head in Munich were originally carved for Prince Ludwig of Bavaria and descended together to the Munich museum (the bust signed and dated 1812); and that the bust carved for Quatremère and the full-length for Josephine must have entered the Hermitage together.[5]

There is no basis, however, for identifying the Hermitage bust with that carved for Quatremère; in fact, examination of the records readily disproves this. In the catalogue for the auction of Quatremère de Quincy's effects, which took place at his residence, number 14, rue de Condé, Paris, on Monday, April 22, 1850, the bust is described as having the dedication noted above and is listed as fifty-four centimeters high with a socle sixteen centimeters (total seventy cm).[6] Yet the Leningrad bust does not bear any inscription, and its measurement is given as sixty-six. The Art Institute bust has both the inscription and the requisite height. Since it was in a South American collection subsequent to its sale at another Paris auction in 1908, few scholars knew of its existence, which probably accounts for the fact that it has not until now been identified as Quatremère's bust.[7]

Correspondence between Canova and Quatremère clarifies the history of the bust, its relationship to the other busts and full-length versions, as well as illuminating the two friends' aesthetic views. Announcing the dispatch of the bust, Canova wrote Quatremère de Quincy on December 31, 1810:

> I was pleased to find that Mr. L.M. sent more than thirty days ago the crate with the head of Paris. I am most impatient for you to see it. Perhaps the marble will seem to you to have been waxed [a reference to the sculptor's occasional and controversial practice of coating his marble surfaces]; and yet it is not true, being part of the larger block, from which you will one day see the statue [the full-sized *Paris* for Josephine, now in Leningrad], by now nearing completion, and which has the same natural color. Then perhaps you will give me your candid opinion about this piece of sculpture on which I have labored with such love, with the idea, too, that it might be of some use to you.[8]

He had never indicated that it would be a gift to his valued friend. Evidently it was intended to be a surprise. Quatremère stated in his biography of Canova that the artist was especially fond of the *Paris*, repeating the head several times, and "sending one to me with an inscription as witness of friendship."[9] On March 16, 1811, the critic wrote to thank Canova for the gift, declaring: "There is in him a mixture of the heroic and the voluptuous, the noble and the amorous. I do not believe that in any other work you have ever combined such life, softness, and chaste purity."[10]

Other comments on the bust from a prominent French artist, a man of letters, and a collector indicate its favorable reception in Paris. The painter Jacques Louis David praised the work. The writer Stendhal also sent words of admiration through Quatremère to the sculptor.[11] But the most interesting reaction was that of Josephine. The former empress was such an avid collector that she turned her home at Malmaison into a virtual museum. Although she owned numerous works by young French sculptors, including Bosio, Car-

FIGURE 2. Alternate view of fig. 1.

FIGURE 3. Engraving of a colossal self-portrait by Antonio Canova. This engraving by Théodore Richomme (1785–1849) was the frontispiece of Quatremère de Quincy, *Canova et ses ouvrages ou mémoires historiques sur la vie et les travaux de ce célèbre artiste* (Paris, 1834). Quatremère had encouraged Canova to sculpt such a bust in 1812 and illustrated it in his biography of the sculptor.

tellier, and Chaudet, Canova was her favorite.[12] She passionately sought his work, obtaining two copies carved by Canova, the *Standing Cupid and Psyche* (Paris, Musée du Louvre; 1796–1800) and *Hebe* (Devonshire, Chatsworth; 1808–14) and two original statues, *Dancer with Hands on Hips* (Leningrad, The Hermitage; 1806–12) and *Paris*. Both of these last, shown at the Salon of 1812, elicited "universal praise," although it was especially the *Dancer* that finally established Canova's fame in France. In addition, in 1810, Josephine commissioned *The Three Graces* (Buckinghamshire, Woburn Abbey; 1815–17), a work finished only after her death in 1814. Divorced and exiled to Malmaison, "among all these smooth marbles, evocations of love and eternal youth," Josephine attempted to forget her downfall.[13] In this setting, Quatremère viewed the full-length work for the first time and wrote to Canova on February 27, 1813: "Your *Paris* is a piece worthy to rank with the most beautiful antique. This is what everyone says, and I say it with them. I studied it for three hours and my admiration never faltered."[14] Quatremère then catalogued the specific qualities he found in the work:

> Simplicity and variety in composition, grandeur of style, truth to nature, character appropriate to the subject, which is the very ideal of a Paris, correctness in the whole and the details, harmony in the contours, firmness and suavity in the forms, beauty in all the aspects and in the general movement, enchantingly suitable expression of the head, successful use of accessories, perfect balance of all the parts, and the charm of life suffused throughout with no hint of labor.

With characteristic humility and gratitude, the sculptor replied:

> I am infinitely happy that the Empress Josephine has complied with my wish, having you come to see Paris. . . . It is impossible to say in words how I feel . . . for your expression of understanding and the praise you have awarded my work. . . . Ah, if you could see my heart, you would know how full of joy . . . and triumph to have earned your outpouring of true friendship.[15]

Quatremère apparently left his bust for a time at Malmaison. Josephine alternately preferred the bust and the statue, unable to decide which was more successful and equally unable to convince Quatremère to part with the bust. Quatremère recounted his own experience before the two works:

> I hurried to see the statue The replica of the head that I had received aroused in me the strongest desire to know the whole As to the Head considered alone, I must say that I never have been able to regard it as what one ordinarily calls a "copy." I regard it as having received from his hand a deliberate and entirely new finish, especially since a comparison with the original revealed notable differences—whether in the mouth, in the eyes, or in the execution of several other details. This was quite evident to Josephine: Having compared the two, she mused on seeing me, "Would that one could put your Head on my statue in place of mine!"

"No," I answered, "it should not be done, even if it were possible, since both would suffer. Mine would be less effective on your statue, and the head of the statue would have less charm, if it were that of my bust."[16]

Fortunately, Josephine's whim went unfulfilled. But their discussion, however fanciful, and the correspondence between the two men, however effusive, clarifies the relationship that they perceived between statue and bust. Canova carved the bust mid-way during the six-year period he labored over the statue. For the sculptor, it was neither a preparatory study nor a copy but a showpiece to demonstrate a particular side of his art to a man whose opinion he valued. Interestingly, Quatremère found it necessary to defend the validity of his bust as a work of art in its own right. In his 1834 monograph on the sculptor, he denied, as we have seen, that the bust is a "copy" in the ordinary sense, since it is not identical with the head on the statue and is finished differently. This implies that the bust is a variation of the original (the statue), and indeed it is the sensitive, glowing face that attracts us and that Quatremère found so alluring ("life, softness, and chaste purity") as opposed to merely the successful balance between head and body of the statue ("enchantingly suitable expression of the head"). Nor does the bust precisely fit another category of Canova's work, what he called his *teste ideale*, or ideal heads. These busts were often based on the sculptor's earlier statues. But in these heads he expunged specific detail. Through contemplation of the features of a human face more as abstract composition than as representation of a historical or legendary individual, Canova sought to guide the viewer to universal beauty.[17]

The *Bust of Paris* falls between various types of work: preparatory study, copy, ideal head. Perhaps Canova carved it as an act of self-correction to balance his work on the statue. And because of the success he perceived in the work, he sent it to Quatremère as much for his opinion as in friendship. Certainly the hesitation of Quatremère and Josephine before the two works gives us to understand that they viewed the bust as the more successful of the two heads of Paris, even if the statue was more important by virtue of its scale. The sense of artist and critic that the bust is an extraordinary demonstration of the sculptor's powers separates it from the other versions of the *Bust of Paris*, most of which are likely to have been commissions in which the sculptor himself was less involved, workshop copies, or simply copies of unknown derivation. The bust for Quatremère is the only one of the known busts for which written testimony from the sculptor exists to prove that Canova carved it himself, indeed, that he was particularly proud of his work. In the case of a sculptor with so large and efficient a workshop, capable and even organized to produce replicas, it is valuable to know that the version in Chicago is the one clearly from the hand of the artist himself.[18]

Finally, we need to explore the relationship of these two men to understand better the nature of their discourse about the bust. Both were unmarried, though Quatremère lived a more solitary life and Canova surrounded himself with people—a woman painter kept his house, his half-brother was his secretary, and his childhood friend and later biographer, Antonio d'Este,

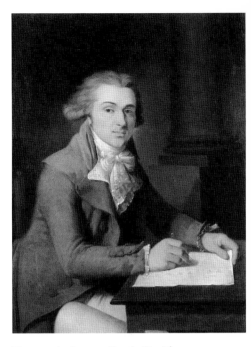

FIGURE 4. Jacques Louis David (French, 1748–1825). *Portrait of Quatremère de Quincy*, 1779. Oil on canvas; 91 × 72 cm. Private collection. Recently rediscovered, this is a portrait of the critic as antiquarian, drafting a plan of an ancient building during his first trip to Italy. Ironically, David added an inscription of friendship to the portrait of Quatremère, whose death warrant David signed during the French Revolution.

directed his extensive studio practice. Remaining single, both devoted themselves to the arts; today, we would call them "workaholics." While Canova was known for his even temperament, diplomacy, and natural simplicity, Quatremère was a misogynist and a prickly, difficult personality.

Canova was the greatest sculptor of his day and, at the height of his career and long after his death, the most famous artist of the Western world. As supervisor of the Greek and Roman sculpture collection at the Vatican, Canova was in a position to influence attitudes toward antiquity. His own works such as *Cupid and Psyche* (Paris, Musée du Louvre; 1787–93), *Perseus* (New York, The Metropolitan Museum of Art; 1797–1801), and *Paolina Borghese as Venus Victorious* (Rome, Borghese Gallery; 1804–1808) stand among the best known monuments of his period. His success was the product of several factors: his ability to create an artistic form finely attuned to the tenor of the times, his skillful diplomacy with nearly all the crowned heads of Europe and many leading statesmen and men of letters, and shrewd merchandising supported by a large and disciplined workshop capable of meeting the ever-growing demand for his work.

His fame was further spread and carefully nurtured by the leading Neoclassical theoretician Quatremère de Quincy, who lost few opportunities to champion the artist. Although originally trained as a sculptor himself, Quatremère de Quincy established his reputation with a series of theoretical treatises, biographical studies, and archeological reconstructions. His notoriety was assured by his dogmatic stance, his royalist political views, and his great influence over the nascent sciences of aesthetics and archeology, as well as over the production of works in France. As permanent secretary of the French Académie des Beaux-Arts from 1816 to 1839, he imposed a rigid standard of classical values on the official French art world.[19]

The sculptor and the critic were introduced in 1783 by the English collector William Hamilton. Canova had recently moved from his native Venice to Rome, where he heralded his arrival by unveiling two important marble groups. The first, *Daedalus and Icarus* (Venice, Museo Correr; 1777–79), exhibits a late Baroque manner, filled with detail and sentiment. The second, *Theseus and the Minotaur* (London, Victoria and Albert Museum; 1781–83), was conceived with the pure and severe lines of classical sculpture. Quatremère saw in these two works different paths that the sculptor could take. In the critic's view, Canova was faced with a choice, like Hercules at the crossroads (a popular allegory from mythology): one path led to virtue and one to vice. He urged Canova to step forward from the "banal and vulgar" *Daedalus* group to the *Theseus*, the "very idea of perfection and beauty."[20] In two theoretical works, *On the Ideal in Art* and *On Imitation in the Fine Arts*, Quatremère later defined in writing his twin principles of art: the *beau idéal*

FIGURE 5. Detail of fig. 1. This inscription marks the Art Institute bust as the one given by Canova in friendship to Quatremère de Quincy.

and *belle nature*—the imitation of nature based on idealized types, rather than on specific individual characteristics.[21] At this point in his career, he had not yet published his interpretations of classical art; yet, he possessed sufficient confidence in his ideas to attempt to impose them upon the young sculptor. "To please his new friend and mentor," Gérard Hubert noted, "Canova did his best to restrain his sensual, realist temperament and the fanciful imagination to which his sketches and designs bear witness."[22] He determined to emulate the masters of antiquity and to unite their "severity and simplicity" with his own "sweetness and tenderness of expression."

This encounter not only influenced the development of Canova's style but it also initiated an intellectual dialogue that continued until the sculptor's death in 1822. As the two men resided in different countries, they seldom saw one another; in fact, they met face-to-face only four times during their forty-year friendship. Instead, the relationship centered on a continuous correspondence about Canova's works in progress. From Rome, Canova sent sketches, designs, engravings, and even models of his latest works, soliciting Quatremère's suggestions and direction. Canova was totally sincere when he sought his friend's advice; he accepted it gratefully and was prepared to reconsider works that Quatremère criticized; he even chose to await his written instructions before undertaking certain new projects. From Paris, Quatremère would advise the artist and critique the work in addition to sending his latest publications. An article on funerary art, for instance, prompted Canova to alter his ideas in order to follow the theorist's directions.[23] Several sculptural projects were initiated by Quatremère's suggestions: among them the *Equestrian Monument to Charles III* in the Piazza del Plebiscito, Naples (1807–19) and the Possagno *Pietà* (1819–21).[24] On the authority of the ancients, Quatremère persuaded Canova to use polychromy in details of *Hebe* (East Berlin, Nationalgalerie; 1796), shown in the Louvre in 1808, and his colossal *Religion* (Belton, Lincolnshire, parish church; 1815).[25] When Quatremère complained that Canova's plaster models for the allegories in the *Tomb of Clement XIV* (Rome, Santi Apostoli; 1783–87) strayed from antique iconography, the sculptor smashed them and made new ones according to the critic's advice.[26] Not even studio practice was immune from criticism: Quatremère insisted that the sculptor keep a plaster cast of each finished work as a standard of replication, and Canova complied.[27] His influence over Canova transcended simple advice and approached collaboration.

Despite Canova's enormous reputation in Italy, he was largely unknown in France around 1800. To remedy this, Quatremère arranged the sculptor's entries to the Paris Salon exhibitions of 1804, 1808, 1810, and 1812, promoting them in both scholarly and popular articles.[28] He engineered Canova's nomination as a Foreign Associate of the Fine Arts Class of the Institut de France in 1801, and spent three years campaigning on his behalf and sheltering him from adverse criticism before he was elected.[29] He reveled in the success of the sculptor's first finished marble seen north of the Alps, the *Repentent Mary Magdalen* (Genoa, Palazzo Bianco; 1794/96), at its exhibition in Paris in 1808.[30] And Quatremère defended the sculptor from vicious verbal attacks on the colossal nude statue of *Napoleon as Mars* (London, Apsley House; 1803–1806).[31] Because of the critic's steadfast support, Canova began to

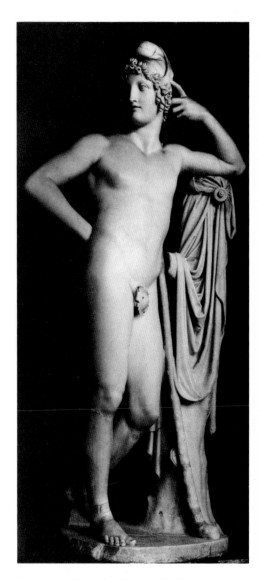

FIGURE 6. Antonio Canova. *Paris*, 1808–12. Marble; h. 207 cm. Leningrad, The Hermitage. This is the full-length version of *Paris*, first displayed by Josephine at Malmaison, but soon after installed in The Hermitage after its purchase by Czar Alexander I.

receive other patronage from the Bonapartes, particularly the former empress Josephine, in spite of the debacle of the Napoleon statue. If the *Bust of Paris* was a reward for devotion, Quatremère had clearly earned it.

A last element of Canova's and Quatremère's relationship was their sharing of political campaigns on behalf of works of art. One joint cause was to urge the return of the treasures and monuments of art that Napoleon and his armies had removed from Italy. In hiding because of his reactionary royalist agitation and unrelenting opposition to Bonaparte, Quatremère had dared to publish the *Letters to General Miranda* (1796), protesting the rape of art from Italy and condemning the "usurper" Napoleon.[32] The fiercely nationalistic Canova applauded his friend's heroic defense of his country's patrimony. After years of effort, the two men together witnessed a successful result, when in 1815 Canova traveled to France to represent the interests of the papacy in the repatriation of these plundered artworks.[33] From Paris, Canova traveled on to London to evaluate the quality of the Parthenon marbles that Lord Elgin had offered the British government for purchase. Canova was stupefied by the "real flesh, the beautiful nature" to be found in Phidias's creations, realizing that the Roman works on which he had based his style were conventional copies when compared with Greek originals.[34] On Canova's urging, Quatremère went to see the Elgin Marbles, and his series of letters to Canova on these works, later published, joined artist and writer in one last shared venture, the promotion of Greek sculpture. Neither man had ever visited Greece, and both were surprised and delighted to find Phidias's art "lively and fleshy." Recognizing their limited knowledge of classical art, they vowed that "all our studies must be begun again."[35]

Canova's death, in Venice in 1822, just four years after the Elgin project, was felt throughout Italy as a national loss, but for Quatremère it was acutely personal. The year after Canova's death, he read an extract of an *Eloge historique* to members of the Institut de France.[36] His biography, *Canova et ses ouvrages*, appeared eleven years later. His constant promotion of Canova's style to the young French sculptors studying at the Académie de France à Rome, through his position as permanent secretary of the Académie, sustained the sculptor's memory long after his death, despite the general stylistic shift to Romanticism. Until Quatremère's death at age ninety-five, Canova's memory was kept fresh in the critic's mind by the sculpture given him by the artist, the *Bust of Paris*. Its presence in his Paris townhouse served to remind Quatremère of the two friends' shared aesthetic principles and artistic causes, as well as to mark the effect his influence had borne on the greatest sculptor of the Neoclassical period.

Neoclassicism on Cloth

CHRISTA C. MAYER THURMAN
Curator, Department of Textiles

Among the vast holdings of the Department of Textiles at The Art Institute of Chicago is an outstanding group of embroidered, woven, and printed textiles from France.[1] Selected for this photographic essay are seven roller-printed cottons reflecting the late Neoclassical style known as Empire, which dominated French decorative arts during the reign of Napoleon I (1804–14). All seven examples were intended to be used either as furnishing fabrics or as wall coverings instead of wallpaper.

Roller printing involves the use of an engraved copper cylinder. This technique for textile decoration evolved from two earlier methods, woodblock printing and engraved copper-plate printing. A didactic display at the Musée de l'Impression sur Etoffes in Mulhouse, France, shows a mannequin engraving a copper cylinder (fig. 1). The pattern on the roller was printed on paper (visible in front of the mannequin) and on cloth (hanging behind it). There were several advantages to using engraved cylinders, among which were speed and the capacity to achieve a greater number of continuously repeated patterns on a more intimate scale than earlier techniques had permitted. The first fabrics printed by this process are, for the most part, monochromatic, since the roller could only print one color at a time. If more than one color was to be incorporated in a design, additional colors were added by printing with wooden blocks.

The engraved metal roller was developed in 1783 by Scotsman Thomas Bell and patented in England. Nonetheless, it was not until after 1800 that this process was used in France, at Jouy-en-Josas, one of the most important French printing centers. The Jouy-en-Josas manufactory, situated along the banks of the Bièvre River near Versailles, was founded by Christophe Philippe Oberkampf (1738–1815). Born in Germany to a talented family of dyers, Oberkampf established his cotton-printing factory in 1759–60 and served as its director until his death.

Oberkampf's remarkable achievement at Jouy-en-Josas, maintained for over half a century through violent political upheaval, is testimony to his genius. The closeness of the factory to Versailles encouraged visits from many members of the court, who became his customers. Named a Manufacture Royale by Louis XVI in 1783, Jouy-en-Josas survived the French Revolution to become highly successful and much honored under Napoleon. He awarded Oberkampf the Legion of Honor and visited the factory twice, in 1806 and 1810. Oberkampf's success was due to his sensitivity to shifts in taste, to his use of high-quality materials, to his adoption of new techniques such as roller printing, and to the outstanding people he selected to work with him. Many fine artists worked for the factory, including the chief designer, the renowned painter Jean Baptiste Huet (1745–1811), who was responsible for at least two and possibly five of the textiles included here, all of which were produced at Jouy-en-Josas.[2]

FIGURE 1. Albert Keller-Dorian, designer. Display of the copper engraving and printing system established at Jouy-en-Josas, France, under the direction of Christophe Philippe Oberkampf (French, 1738–1815), 1922. Mulhouse, France, Musée de l'Impression sur Etoffes (967.193.1). The copper cylinder shown here was actually engraved in 1922 with scenes of World War I. Its dimensions (l. 97 cm; dia. 13.5 cm) are close to those used in the early nineteenth century at Jouy-en-Josas. Few copper-engraved rollers survive today, since they were melted down, especially during periods of war, so that the copper could be reused for machinery and weapons.

FIGURE 2. Jean Baptiste Huet (French, 1745–1811), designer. *Cupid and Medallions*, c. 1810. Jouy-en-Josas manufactory; Christophe Philippe Oberkampf, director. Cotton, plain weave (printed by engraved roller); 93.4 × 85.1 cm. The Art Institute of Chicago, gift of Mrs. Murray Fuchsmann in memory of her mother, Mrs. Bertha Stenge (1957.632). All of the textiles reproduced here were produced at Jouy-en-Josas under Oberkampf's direction, were printed by engraved roller on plain weave cotton, and are from the Art Institute's collection.

Cupid and Medallions was designed by Huet around 1810.[3] Here, various configurations of putti—alone and paired, flying, standing on consoles, carrying garlands—alternate with classical wreaths containing warrior masks or doves in flight. An arrangement of fruit, torches, and trumpets is repeated against a solidly patterned background of hearts. Although the vocabulary of repeated motifs here is reminiscent of the Rococo style, the tightly organized composition and almost mechanized background pattern make the design Neoclassical. Both the background and the individual motifs were printed simultaneously in red over the natural cotton fabric. The design was also printed in at least one other color.[4]

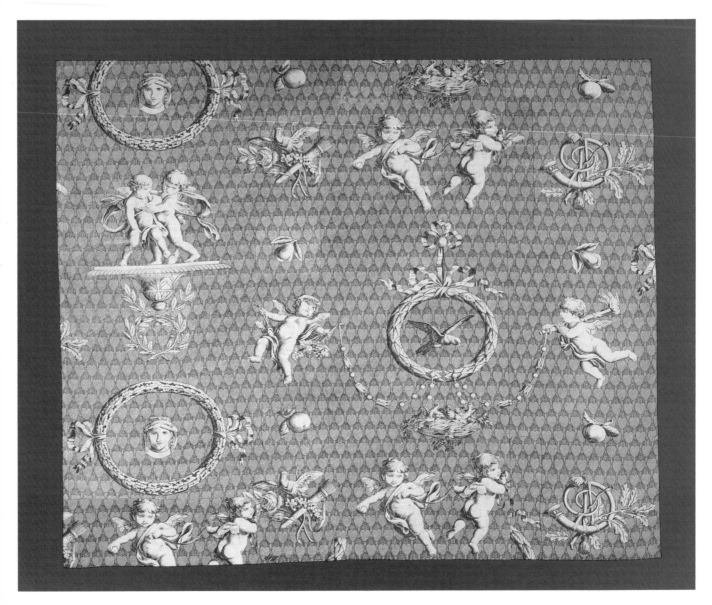

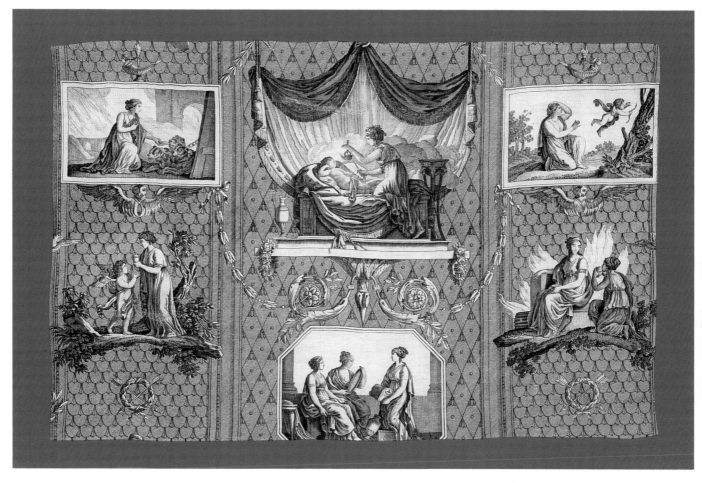

FIGURE 3. Jean Baptiste Huet, designer. *Cupid and Psyche*, 1810. 41.2 × 65 cm. Gift of Robert Allerton (1925.154).

This elaborate composition, made up of a wide band of motifs flanked by two narrower bands, was created by Huet in 1810.[5] The textile features, in alternating framed and unframed scenes, the popular story of Psyche and her misadventures with Venus and Cupid. The unframed, central scene, for example, emphasized by elaborate swags of drapery above and garlands below, shows Psyche breaking her vow not to look at Cupid. The panel is an example of Huet's last decorative style, in which he worked with all-over compositions incorporating variously framed classical motifs and figural subjects. It also demonstrates Huet's ability as a draftsman; the scenes reflect the influence of the versatile French painter and sculptor Pierre Paul Prud'hon (1758–1823), who did a series of similar compositions. In the two narrower, flanking bands, the narrative images are linked together by a background grid of continuous hearts; those in the center band by one of diamond shapes. Examples in other collections document that the pattern was printed in various colors.[6]

When Huet died in 1811, Oberkampf found it difficult to replace him. He finally settled upon Hippolyte Lebas (1782–1867), a prominent architect. Lebas had studied with the famed Neoclassical designers Charles Percier and Pierre François Léonard Fontaine, who served as architects to Napoleon and were central in the creation of the Empire style. One of Lebas's masterpieces for the Jouy-en-Josas factory is *The Monuments of Paris* of 1816/18. The pattern features four Parisian landmarks: the Pantheon, the Colonnade of the Palais du Louvre, the statue of Henri IV on the Pont-Neuf, and the Fountain of the Innocents. The shape of each is echoed by the form of the frame surrounding it. Connected to each motif are medallion portraits of the sovereign during whose reign each monument was erected: Henri II, Henri IV, Louis XIV, and Louis XVI. These grandiose images and their elaborate frames, surrounded by a unifying background pattern, are typical of the bombast of which the proud, nationalistic Empire style was capable. The boldness of the composition is reinforced by the choice of a purple and yellow color scheme, seen against the natural cotton fabric. This effect was achieved by first printing the purple with an engraved roller and then adding the yellow with a wooden block.[7]

FIGURE 4. Hippolyte Lebas (French, 1782–1867), designer; Nicolas Auguste Leisnier (French, 1787–1857), engraver. *The Monuments of Paris*, 1816/18. 71.9 × 72.5 cm. Gift of Robert Allerton (1924.817).

FIGURE 5. Hippolyte Lebas, designer.
The Merchant of Love, 1815/17.
99 × 95.2 cm. Gift of Mrs. Lawrence
McClure (1966.146).

The Merchant of Love was a favorite theme among French Neoclassical artists,
after the discovery of a composition in an ancient fresco uncovered in Italy in
the eighteenth century. The gentle eroticism and graceful forms of Roman
paintings were easily adapted to a decorative function. Thus, in fabrics like
this one from Jouy-en-Josas, motifs that had decorated the walls of Roman
villas were incorporated into early nineteenth-century interiors. The motif
that gave its title to this textile was inspired by an engraving Prud'hon
executed of one of his most popular compositions. The four bands that
comprise this design include a variety of shapes—octagons, hexagons, ovals,
circles, diamonds, and shields—all set against a tiny grid of diamonds.[8] The
ornate design resembles a string of precious ancient cameos. The rich vocabu-
lary of motifs includes putti, musical instruments, animals, such as swans,
pelicans, and butterflies, as well as tritons and other references to sea life.[9]

At the left of *Cupid Triumphant*, in the iris of an eyelike oval shape, Venus is
seen being held in bondage by Cupid. At the right is an equally complex
form: a medallion enclosing the profile of Mercury and a rectangle enframing
a fox and a lamb, over which sit two addorsed sphinxes. Separating each band
of repeated motifs is a row of rosettes alternating with warrior heads. The
motifs, most of which are circular or at least curvilinear, are further related
by the tiny continuous circles that comprise the background. The fact that the
background pattern relates to that of *The Monuments of Paris* (fig. 4) suggests
that *Cupid Triumphant* could also have been designed by Lebas. On the other
hand, Huet was particularly fond of using animals in his designs. Thus, it is
possible that he created the design for this textile, which was produced several
years after his death.[10]

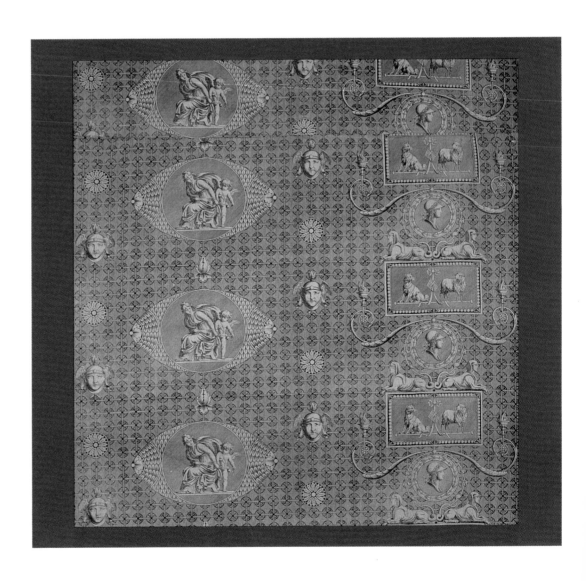

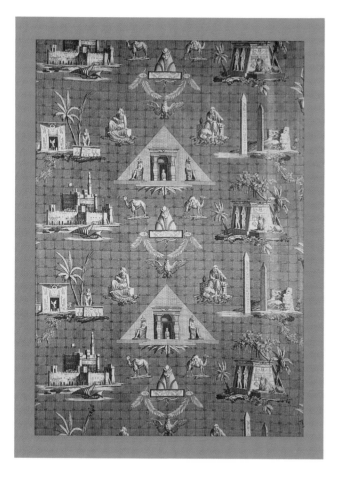

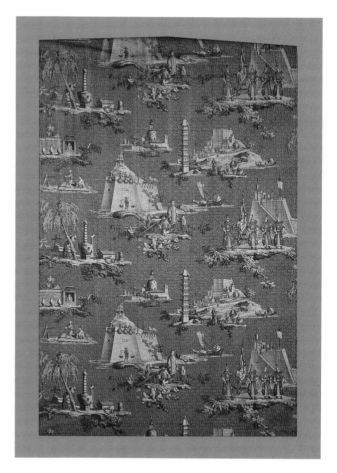

FIGURE 7. Jean Baptiste Huet or Hippolyte Lebas, designer. *The Monuments of Egypt*, after 1802 or, more probably, 1815. 249.9 × 95.6 cm. Restricted gift of Mrs. Julian Armstrong, Jr. (1976.89).

FIGURE 8. Jean Baptiste Huet or Hippolyte Lebas, designer. *The Monuments of China* or *The Chinese*, either 1805/15 or 1815. 239.1 × 96.9 cm. Restricted gift of Mrs. Julian Armstrong, Jr. (1976.91).

The Monuments of Egypt reflects the French vogue for Egypt prompted by Napoleon's North African military campaign in 1798, which resulted in the proliferation of Egyptian motifs on furniture, silver, ceramics, and fabrics. Always aware of the persuasive power of images, Napoleon was accompanied to Egypt by a team of artists who recorded not only the victories of the French army but also accurate descriptions of Egyptian buildings and their decorations. The drawings these and other artists made were quickly engraved and included in a number of books that achieved wide circulation throughout Europe. Thus, such exotic images took on political and patriotic significance for the expanding French nation. The nine different vignettes of this composition are derived primarily from plates in Louis François Cassas's *Voyage pittoresque de la Syrie, de la Phénicie, de la Palaestine, et de la Basse Egypte*, published in Paris in 1802. Among the scenes featured here are a pyramid whose columned en-

trance is flanked by statues of Anubis, the obelisk of Cleopatra, the museum and library of the Ptolemies, a view of the great Pharillon in Alexandria, the great Sphinx, and three Egyptian tombs.[11] Additional images showing seated and kneeling figures in regional costumes, camels, foliage, and an owl with widespread wings complete the composition.[12]

Closely related to *The Monuments of Egypt* is this printed cotton designed either by Huet or Lebas. Chinese subjects had been popular with European decorative artists since the middle of the eighteenth century. The depictions of Chinese motifs in this printed cotton were certainly inspired by illustrated volumes about travel to exotic foreign lands, but precise sources have yet to be found. Images of fortresses, pagodas, civilians, and warriors are interspersed with smaller compositions showing aspects of domestic life in China. The background consists of a continuous semicircular shield motif.[13]

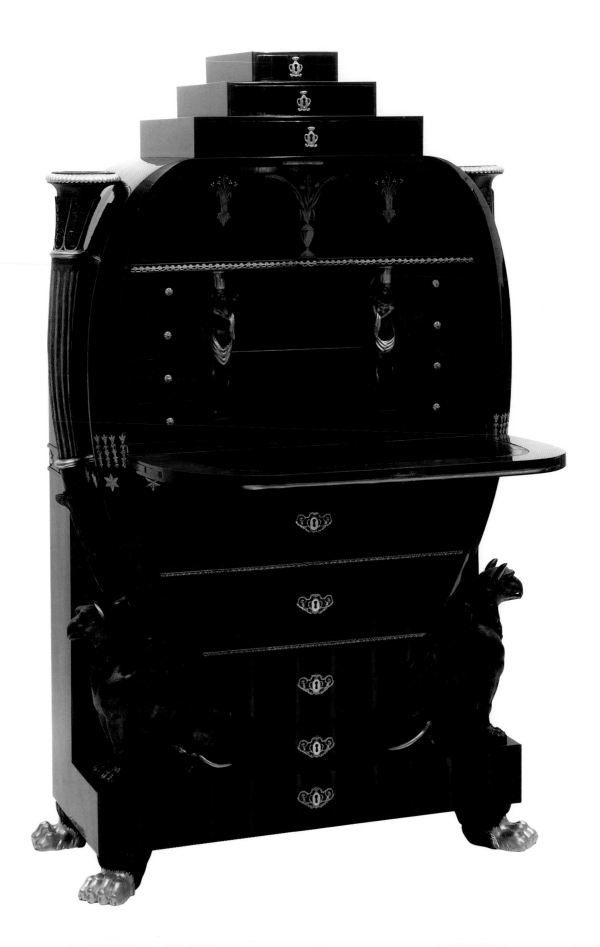

A Viennese Secretary in the Empire Style

CHRISTIAN WITT-DOERRING,
Oesterreichisches Museum für angewandte Kunst, Vienna

*I*n 1976, The Art Institute of Chicago purchased a secretary from a New York art dealer (figs. 1–2).[1] Because of its supposed provenance and a signature and date impressed into the back panel of the secretary, it was thought to be the design work of the French team of architects Charles Percier (1764–1838) and Pierre François Léonard Fontaine (1762–1853), from the year 1812.[2] After a critical analysis of its style and a comparison with secretaries of similar form, this assumption can no longer be maintained.[3] Rather, its decorative manner and distinctive lyre shape indicate that it is the work of a Viennese master cabinetmaker, from the period around 1810,

FIGURE 1. Austrian (Vienna). Secretary (shown open after latest restoration in 1989), c. 1810. Unidentified woods, limewood, carved, gilded, and painted in patinated bronze color, with gilt-bronze mounts; interior: copper, brass, and maple wood marquetry, with mahogany and yew; 146.5 × 91.2 × 39.2 cm. The Art Institute of Chicago, Centennial Fund Purchase (1976.39). Photo: Georg Mayer.

whose identity is still unknown. The type represented by the Art Institute piece derives from the eighteenth-century *secrétaire à abattant*, or drop-front writing cabinet, which was very popular in France in the second half of the eighteenth century.[4] Examples of the lyre-shaped secretary were first created in Vienna about 1800/1805. In the early nineteenth century, Viennese cabinetmakers concentrated all their creative powers and skills on the lyre-shaped secretary, which became, in fact, the most elaborate form produced in Vienna in the Empire style, spreading, as we shall see, in use through other areas influenced by German or Austrian culture.

Since the determining factor in the original misattribution of the Art Institute's secretary was the signature, the reattribution process should logically begin with this point. Starting in 1743, the cabinetmakers' guild in France (*corporation des menuisiers-ébénistes*) required every master cabinetmaker to mark his furniture with his signature. This requirement was maintained until the French guilds were abolished in 1791. From then on, each cabinetmaker could decide whether or not to sign his products. The signature of the two architects, Percier and

55

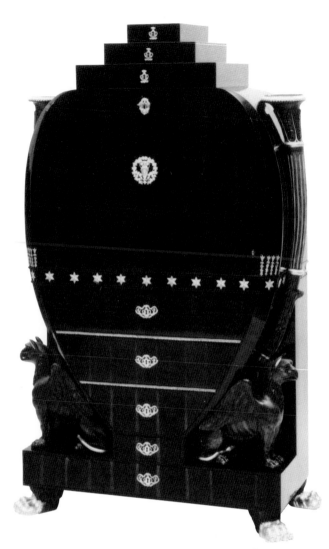

FIGURE 2. Austrian (Vienna). Secretary (see fig. 1; here shown closed after 1989 restoration), c. 1810. Photo: Georg Mayer.

FIGURE 3a–b. Austrian (Vienna). Secretary (see fig. 1; shown open and closed after restoration in 1976), c. 1810.

Fontaine, which is impressed into the secretary in various places and in various ways, is unique and unusual in many ways; for this reason alone, it should arouse suspicion. To our knowledge, no piece exists that is designed and signed by Percier and Fontaine. Likewise, there is no piece of French furniture that carries the signature and date of its designer in a manner similar to a cabinetmaker's impressed signature.

The appearance of two different forms of the signature is also highly unusual: twice with a full last name, COMPOSE PAR C. PERCIER ET PFL FONTAINE MDCCXII, and several times by initials, CP ET F. The separation of the signature FONTAINE into "FON/TAINE" for lack of space in one location on the back panel is particularly questionable.[5] Signatures were always cast from one piece of iron in the form of a stamp and were not broken down into individual components that would allow the letters to be arranged in different ways. Finally, in view of such an effort to provide information on the authorship of the piece, one would certainly expect to find the name of the actual cabinetmaker as well. These observations regarding the signature raise the question: "How did it get on the secretary and why is it there?" If we consider that the only extant document written after the secretary was made, an auction catalogue of 1905,[6] does not indicate the existence of a signature, it is tempting to assume that it simply did not exist in 1905. Like the "French" origin of the piece, which was noted in the catalogue, the presence of such an important signature would certainly have been mentioned as a special sign of quality.

According to the provenance that has traditionally accompanied the secretary, it was supposedly a present from Napoleon I to the wife of his marshal Michel Ney (1769–1815). This history has been confirmed solely by the description of the object in the 1905 auction catalogue, which is itself based on information in an auction catalogue of 1892.[7] Because the latter publication, which does not list the secretary at all, was used as the basis for further speculation on the piece's French history, the truth about the Chicago piece became increasingly obscured. The Art Institute curator who purchased it

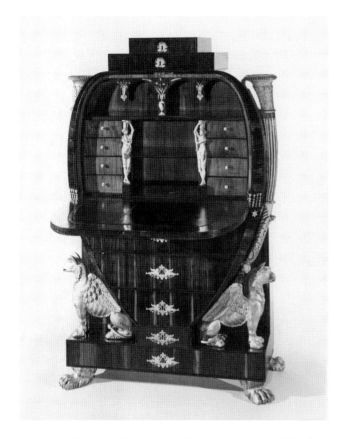

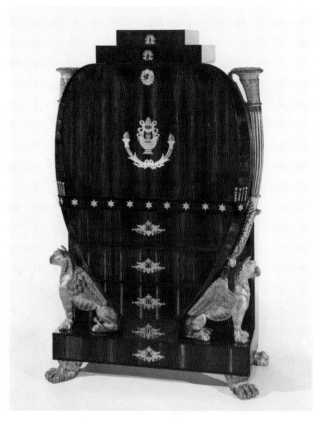

recognized correctly that the keyhole mount affixed to the exterior of the drop-down writing surface, which is decorated with the Bourbon lily and crown, was not appropriate to an imperial Napoleonic piece of furniture, since it refers to the restored French monarchy.[8] He also noticed that a dark shadow in the veneer underneath the escutcheon did not coincide with the outlines of the current escutcheon and concluded that it must have come from the original one. However, this French, lily-decorated mount was interpreted not as a later addition to the secretary but as the tangible symbol of a change in political power: after Napoleon's overthrow, Marshal Ney switched political camps and became a faithful servant of the Bourbons. From this, it was concluded that Ney had the mount changed to reflect his political shift and that the original mount must have been gilt-bronze, decorated with an "N" for Napoleon and the Napoleonic bees.

Based on the conviction that the secretary was French, the piece was "restored" in Chicago in 1976 (fig. 3a–b). Delicate bands of gilt-bronze leaves affixed between the individual drawers in the front as the top border and in

their interior were removed because they were not considered appropriate to a piece of furniture in the French Empire style, nor did they accord with the other drawer mounts and the center mount of the drop-down writing surface, all of which seem to be composed of decorative details typical of the designs of Percier and Fontaine. These mounts can be compared with examples in the influential pattern book published by the two architects, *Recueil des décorations intérieures.*[9]

Because of the information—in this case, misinformation—conveyed by the Art Institute secretary's decorative details, its essential "mood" was ignored. Its overall impression is not that of a French Empire piece. In fact, its lyre-shaped form, resting on a pedestal, is not known ever to have been produced in France (or England, for that matter).

The abundance of existing Viennese examples of this type, coupled with its popularity as a draftsmanship model for craftsmen, suggests that it was a form developed independently by Viennese furniture makers.[10] Nonetheless, this fact was not considered when the piece

FIGURE 4. Drawing for a Viennese lady's dressing table to be executed in mahogany with ebony marquetry and carved wood covered with bronze varnish. *Journal des Luxus und der Moden* (Weimar), 1896, pl. 30.

was acquired by the Art Institute and attributed to France. Perhaps this mistake was made because the secretary shares with French pieces of the period the use of broad expanses of undecorated veneer, punctuated by restrained, classicizing mounts. The resulting monumental quality and the strongly symmetrical forms are two of the most striking characteristics of furniture made in the French Empire style around 1810.

Unlike contemporary French pieces, however, the Art Institute secretary is overwhelmed by an abundance of decorative and structural details in a manner that is more typical of late eighteenth-century decoration than of the Empire period. For example, the two griffins, looking rather like domesticated pets, do not provide a sufficiently strong counterweight to the front, whose gravity is further diffused by decorative ornaments used to divide the piece into its individual functional parts (drop-down writing surface and drawers). While the cabinetmaker attempted to create the impression of a flat surface by using a veneer to cover the entire front, he then counteracted this effect by enhancing the contour of the lyre-shaped form by placing a strip of beveled, contrasting dark veneer along its edge. The center of the piece (the joint between drawer support and drop-down writing surface) is emphasized by the addition of flat moldings, which are glued on, and the space between them, filled with hexagrams, gilt-bronze stars. Continuing the horizontal divisions consistently toward the bottom of the case, the divisions between the next three drawers are marked by the tiny bands of gilt-bronze leaves cited earlier as having been erroneously removed. In the restoration of the Art Institute Secretary prompted by the research reflected in this article and undertaken in Vienna this past year, some of the original mounts, supplemented by replications, were put back on the piece. The two

griffins and four paw feet, as well as the two cornucopiae that frame the oval case on both sides, are carved from limewood patinated in bronze color and partly gilded. A description of the secretary's condition prior to its 1976 restoration lists these items as originally covered in a material simulating gold leaf,[11] which was not done in an expensive French piece of furniture of this kind.

The above observations indicate very definitely that the secretary's origin was Vienna. The coexistence of contemporary and old-fashioned elements is typical of Viennese Empire furniture around 1805–15 (a style that was called Josephine).[12] This style, which took as its starting point a furniture corpus still rooted in the tradition of the late eighteenth century and dressed it up with fashionable items such as escutcheons and carvings from the Empire repertoire, can be found in countries such as England and Austria that were not directly politically dependent on France.

The secretary's craftsmanship and materials give additional support to a Viennese origin. The materials themselves reflect the pastiche nature of the piece in general; that is to say, the secretary looks to be composed of many different parts and materials. Both hard (oak) and soft woods were used to construct the core, a frequent characteristic in expensive Viennese furniture. Particularly striking is the choice of materials in the interior of the secretary, where yew was used for the drawers, in addition to the marquetry made of wood, brass, copper, and penwork (a technique of decorating veneered furniture surfaces with black India ink and a fine quill pen that was pretty much out of fashion in France by this time). The woods were selected to create a definite contrast between light areas and dark borders. The sculpted decorations also tend to incorporate many different decorative details, as if put together from a product catalogue, and consequently lack uniformity in design and workmanship. These decorations and mounts were likely purchased individually by the cabinetmaker in a special store for furniture decorations and mounts; he then distributed them across the surface of the piece.

Such a process reflects an attempt on the part of the cabinetmakers to reach an expanding group of customers. Luxury products were now being made available to consumers—noble or bourgeois—in the form of less expensive, ersatz materials. Ornamentation no longer had to be made exclusively of gilt-bronze, but was available in pressed sheet metal and painted or gilded wood.[13] Clearly, these were used with a proud awareness of the technical innovations they represented. The recently undertaken restoration of the secretary revealed that the carved wooden decorations on both the outside and inside were mainly painted in a dark green, which at the time was called *verde antico*, meaning simulated old bronze (see figs. 1–2), a finish that was new at the time and very popular.[14]

Judging from all the known lyre-shaped secretaries that can be found today in public and private collections, it is clear that this type enjoyed wide popularity in the central European region, including Austria, Germany, and Hungary, during the period 1805–40. The majority originated in Vienna, although examples were produced in other areas of the Austro-Hungarian Empire and in Germany as well. Most of them date from the years around 1810–15, but in provincial areas, a few examples can be found dating from around 1840. The earliest evidence of a lyre-shaped piece made in Vienna is an illustration in a German art and fashion magazine from 1806,[15] which specifically presents the piece of furniture as a "Viennese lady's dressing table" (fig. 4). The text emphasizes the fact that the sculptured decorations, consisting of two carved dolphins, are "covered with a delicate bronze varnish," thus providing another contemporary proof that less costly materials and processes were being employed to make luxury furniture. A number of cabinetmakers' drawings can be used as aides in dating this type of secretary. They were executed either in the cabinetmakers' trade schools as part of the curriculum and therefore were based on models, or they were done later to record a completed masterpiece, the final requirement of every cabinetmaker's training. The Akademie der bildenden Künste in Vienna conserves a fairly large number of the latter type of drawings. In their architecture class, the journeymen-cabinetmakers had to demonstrate their ability as draftsmen before being allowed to begin work on their masterpiece. Three such drawings depicting a lyre-shaped secretary are signed and dated 1810, 1813, and 1814, respectively (figs. 5–7). Their composition and abundance of decoration closely resemble those of the

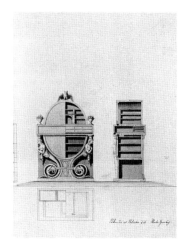

FIGURE 5. Martin Hiernbach (?) (Austrian, act. Vienna). School drawing for a lady's secretary, Nov. 30, 1810. Ink, pencil, and wash on paper; 63 × 48 cm. Vienna, Kupferstichkabinett der Akademie der bildenden Künste (16/103-15059).

FIGURE 6. Johann Ertl (Austrian, act. Vienna). School drawing for a writing desk, 1813. Ink, pencil, and wash on paper; 45 × 34 cm. Vienna, Kupferstich-kabinett der Akademie der bildenden Künste (16/103-15070).

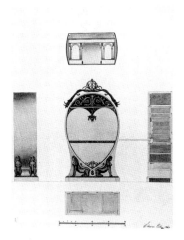

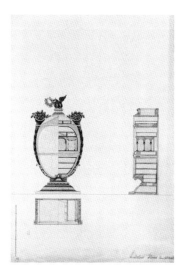

FIGURE 7. Ladislaus Körösi (Austrian, act. Vienna). School drawing for a secretary, Nov. 25, 1814. Ink, pencil, and wash on paper; 63 × 48 cm. Vienna, Kupferstichkabinett der Akademie der bildenden Künste (16/103-15025).

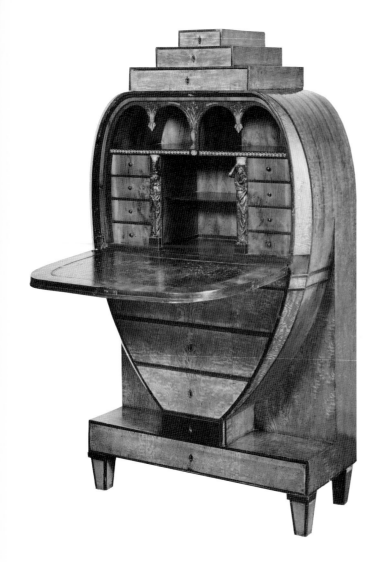

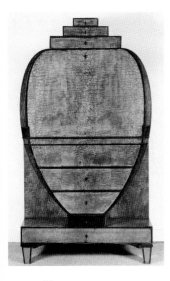

FIGURE 8a–b. Austrian (Vienna). Secretary, open and closed, 1810. Ash wood and wood with dark stain; interior: marquetry in copper, brass, maple wood, and yew, carved and gilded wood partly painted dark, with gilt-brass mounts. Photo: Kenneth Clark, Banstead, Surrey.

secretary in Chicago. It is possible to relate these drawings to entries in the archive of the Viennese cabinet-makers' guild.[16] They tell how much time, from the submission of the design to its completion, was necessary to make such a secretary. The guild set a period of up to four months for completing the masterpiece; in actuality, it usually ranged between three and five months.

Among the preserved examples, a secretary on the New York art market (fig. 8a–b) is particularly useful for comparison with the Chicago piece, since it is a simplified version of the Chicago secretary. Both were probably made by the same Viennese master cabinetmaker. The interior arrangement of the two secretaries is identical except for minor differences in the two caryatids. The exterior look of the New York secretary is different, in that it completely lacks any metal or carved decorations. It is pure volume, composed of individual surfaces covered with expensive ash veneer and bordered by strips of veneer stained in black. The deliberate play between deep yellow, lively grained ash and the severe, quiet, black borders creates an exciting yet harmonious contrast. The piece is typical of Viennese furniture of the early nineteenth century.[17] The New York example still has its top drawer, which was missing in the Chicago secretary, its existence attested to by the missing section of the top-drawer veneer.

A secretary in Vienna's Oesterreichisches Museum für angewandte Kunst (fig. 9a–b) is very similar to the Chicago secretary in craftsmanship and effect. The composition of the Viennese example is perhaps slightly more harmonious because the cornucopiae are more closely integrated into the contours of the piece. Otherwise, both examples show an abundance of small decorations distributed across the surface and made of pressed, gilded sheet metal, and wood painted to look like bronze. Another example very similar to the Chicago secretary recently appeared on the Paris antique market (fig. 10a–b).[18] It presents an overall identical shape with two drawers on the top (photographs do not reveal whether there are signs of a former third drawer). Its decoration is more complicated than that on the Chicago piece. Instead of carved and gilded ornamentation, extensive penwork covers both the inner and outer surfaces. Moving now to areas outside Vienna to which the lyre-shaped secretary spread, we can consider examples from Thuringia and Hanover, where the form was particularly popular. The Thuringian type, which combines the shape of a lyre and a vase, almost completely eschews actual surface decora-

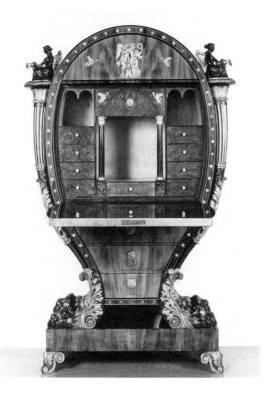
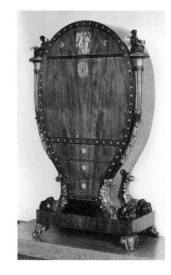

FIGURE 9a–b. Austrian (Vienna). Secretary, open and closed, c. 1810. Mahogany and limewood, carved, bronzed, and painted in black, with gilt-brass and bronze mounts; interior: maple wood and burl wood stained in red, with gilt-metal mounts; 160 × 93 × 40 cm. Vienna, Oesterreichisches Museum für angewandte Kunst (H 2027).

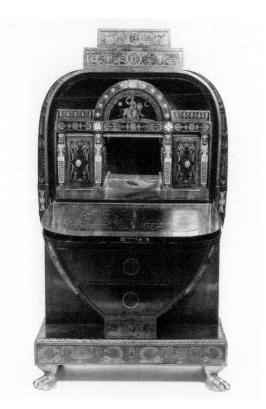
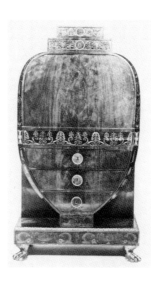

FIGURE 10a–b. Austrian (Vienna). Secretary, open and closed, c. 1810. Mahogany, maple wood stained in black and partly with penwork decoration, limewood carved, gilded, and painted in dark green, with gilt-bronze mounts; 149 × 86 × 42.5 cm. Auction cat.: Paris, Nouveau Drouot, May 9, 1988, cat. no. 66.

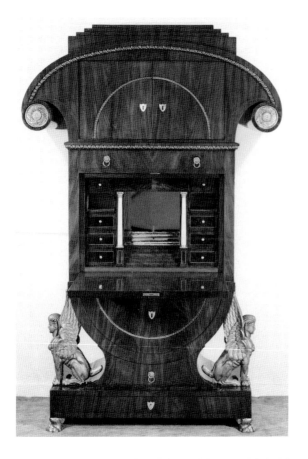

FIGURE 11. German (Thuringia ?). Secretary, open, c. 1820. Mahogany, carved and gilded limewood, with gilt-metal mounts. New York, Didier Aaron Gallery. Photo: Bruce C. Jones, Rocky Point, New York.

tion in favor of the grain of the veneer (see fig. 11). It radiates an architectural monumentality that distinguishes it from its Viennese relatives.[19] The Hanover version, on the other hand, combines the popular cornucopia motif with carved animal paws in addition to patterned mahogany veneer (see fig. 12).

Finally, a group of examples from Hungary, Transylvania, and Vienna illustrate the variety of motifs, drawn from sources as disparate as tomb monuments and musical instruments, that were incorporated into this basic secretary type. The decorative arts museum in Budapest owns two Hungarian versions of the Chicago type of secretary (figs. 13a–b, 14a–b). Their most striking feature is a complicated structure that is both emphasized and blurred by an overabundance of decorative detail. The excessive use of fashionable elements and techniques (penwork and carved decorations) tends to create a somewhat provincial impression. The earlier of the two (fig. 13) features ornaments that are still firmly rooted in the tradition of the Louis XVI period (cut corners, joints that are emphasized by leaf rosettes inscribed in squares, and leaf pendants with portrait medallions). The scene in marquetry on the drop-down writing surface, representing the Italian sculptor Antonio Canova's famous funeral monument for the Archduchess Maria Christina, which was unveiled in the Augustinerkirche in Vienna in 1805, can be used as a terminus a quo. This motif was enormously popular until well into the 1820s. It appears in a variety of ways: on escutcheons made of gilded, pressed sheet metal;[20] on domestic "monuments" made of cast iron, alabaster, and wood; and on another lyre-shaped Viennese type of secretary with a semicircular top border.

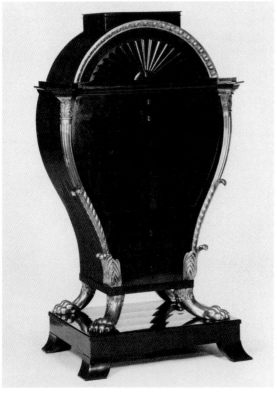

FIGURE 12. German (Hanover ?). Secretary, closed, c. 1815. Mahogany, carved and gilded limewood, with wood stained in black. New York, Frederick P. Victoria & Son, Inc.

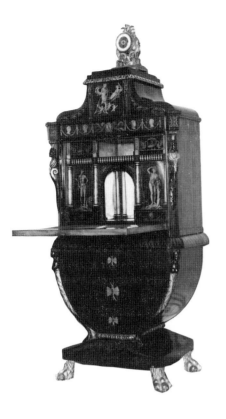

FIGURE 13a–b. Hungarian (?).
Secretary, open and closed, c. 1815.
Mahogany and maple, partly with
penwork decoration, carved wood,
bronzed and stained dark, with
metal mounts. Budapest,
Nagytétényi Kastélymúzeum
(65.203.1).

FIGURE 14a–b. Rumanian
(Kolozsvár/Cluj-Napoca). Secretary,
open and closed, c. 1820. Mahogany
and maple, partly with penwork
decoration, carved wood darkly
patinated and gilded. Budapest,
Iparmüvészeti Múzeum (79.170.1).

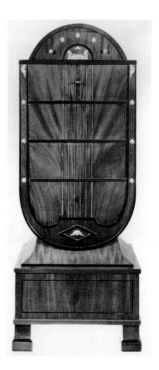

The most beautiful example in this latter group is in the Bayerisches Nationalmuseum in Munich (fig. 15a–b). Here, "strings" have been added to the lyre-shaped piece in the form of six parallel metal rods placed across the front which could make it "resound" like a musical instrument.[21] The interior of the writing compartment contains another domestic monument resembling a tabernacle, which adds to the character of the secretary and elevates this utilitarian object to the status of a memorial. A secretary at a Roman art dealer and differing only with regard to its mounts and legs (which were changed later) must originate from the same cabinetmaker, since both secretaries have the same veneer grain (fig. 16a–b). One more version of this type of secretary recently appeared at auction in New York (fig. 17).[22] The Victoria and Albert Museum in London has a slightly compressed version of this piece that is Hungarian in origin (fig. 18a–b). It is one of the rare central European pieces of furniture to be signed and dated: "*Frantz Steindl 1815 den 30ten Dezember.*" Just recently, a lyre-shaped secretary which is also signed appeared at a Hamburg art dealer (fig. 19). It

FIGURE 15a–b. Austrian (Vienna). Secretary, open and closed, c.1810/15. Mahogany with gilt-bronze mounts; 144 × 78 × 41.5 cm. Munich, Bayerisches Nationalmuseum (66/22).

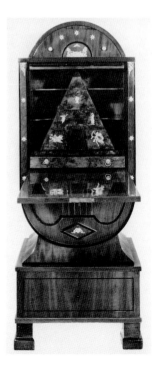

FIGURE 16a–b. Austrian (Vienna). Secretary, open and closed, c. 1810/15. Mahogany and wood stained in black, burl veneer, with gilt-bronze mounts. Rome, art market.

FIGURE 17. Austrian (Vienna). Secretary, closed, c. 1810/15. Mahogany and unidentified wood stained in black, limewood, carved, gilded, and painted in dark green, with gilt-bronze mounts; 102 × 62 × 40 cm. Auction cat.: New York, Christie's, Nov. 24, 1987.

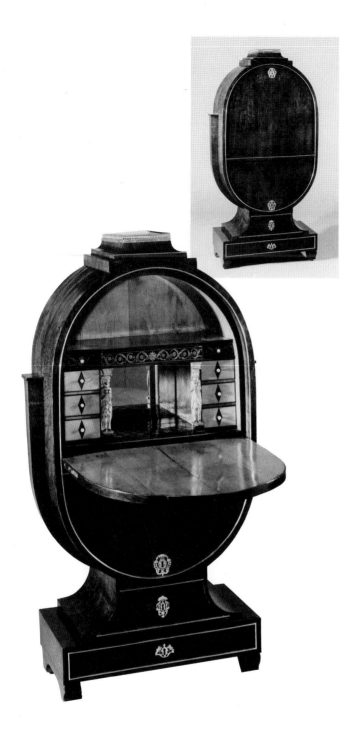

FIGURE 18a–b. Frantz Steindl.
Secretary, open and closed,
Dec. 30, 1815. Mahogany and
maple, partly with penwork
decoration, and bronzed wood,
with gilt-metal mounts; 146 ×
71 × 35.5 cm. London,
Victoria and Albert Museum
(W.22-1981).

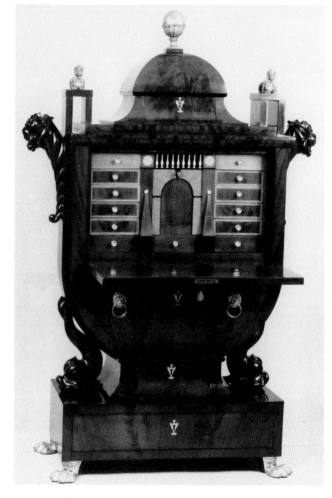

FIGURE 19. H. Meyer.
Secretary, open, 1820. Mahogany,
carved wood, gilded and stained dark, maple
wood, with gilt-bronze mounts; 167 × 147
× 41 cm. Hamburg, Kunsthandlung
Edmund Joachim Kratz.

FIGURE 20. Friedrich Paulick (Austrian, act. Vienna). School drawing for a secretary, small globe table, small work table, and a chair, c. 1815. Ink, pencil, and wash on paper; 32 × 45.1 cm. Vienna, Oesterreichisches Museum für angewandte Kunst (XVIII/d/III 44).

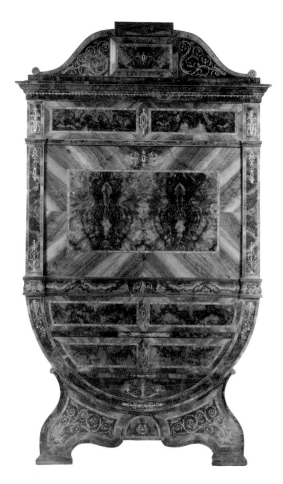

FIGURE 21. Rumanian (Kronstadt). Secretary, closed, c. 1840. Walnut and walnut-burl, birdseye maple, and veined maple wood; 187 × 103 × 55 cm. Vienna, Oesterreichisches Museum für angewandte Kunst (H 2023).

bears the signature *"Anno 1820 H. Meyer"* and is thought to come from Vienna.[23] No cabinetmaker of this name can be documented in Vienna in the year 1820. The formal design is definitely based on the same model as drawings from a Viennese drawing school from the 1810s (fig. 20).[24] However, based on its craftsmanship, it more likely originated in the provinces, which would also explain its late date. One of the latest examples of the lyre-shaped secretary comes from Transylvania (today Rumania) (fig. 21).[25] Its surface is accentuated by profiles and individual veneer sections to a much greater extent than occurs on earlier examples, which also confirms a later date for this piece, of around 1840. The veneer no longer covers the whole front, making it one unified surface, but is treated decoratively like a frame and paneling into which marquetry has been inserted. Its decoration, a mixture of classicizing palmette motifs and foliage tendrils with Gothic-style tracery and crockets, conforms to the new eclectic canon of form that had been predominant in Austria since the early 1830s.

The Viennese lyre-shaped secretaries discussed here illustrate the short but intense life of the form in central Europe. In the 1820s and 1830s, the demand for this form of writing desk had subsided considerably, and by 1840/50, it had disappeared almost completely from the Viennese cabinetmakers' repertoire.

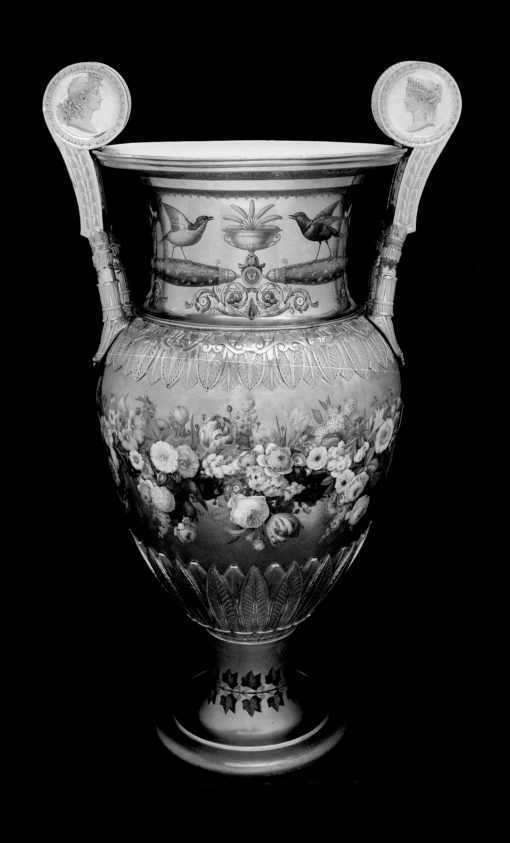

The *Londonderry Vase*:
A Royal Gift to Curry Favor

LYNN SPRINGER ROBERTS, *Eloise W. Martin*
Curator of European Decorative Arts

*E*arly in 1987, The Art Institute of Chicago acquired the *Londonderry Vase*, a most dazzling and sumptuous example of French Empire porcelain (fig. 1). Unlike so many objects in the field of decorative arts that remain anonymous, this monumental object is fully documented in the archives of the Manufacture Nationale de Sèvres. From the time it was ordered by the newly restored Bourbon monarch Louis XVIII to be sent via Talleyrand to Viscount Castlereagh, the second Marquis of Londonderry, the vase's history is known all the way up to its acquisition by the museum.

That the *Londonderry Vase* was a royal gift is indicated in the manner in which its departure from the sale room is recorded in one of the Sèvres registers entitled "Released to the government for presents":

> July 2, 1814 Released by the order of his eminence, the minister of the palace of the king to his highness the Prince of Bénévent: one large Etruscan form vase, four feet in height, scrolled handles in rich porcelain, flowers on the body of the vase, birds and colored ornaments on the neck. All on a gilded ground with rich bronze mounts. 22,000 fr. For cost of packing, 168,60 fr.[1]

Thus, royal decree transferred the vase, known as a *Vase étrusque à rouleaux*, to Charles Maurice de Talleyrand, the Prince of Bénévent (1754–1838), foreign minister to Louis XVIII and one of the shrewdest and most facile statesmen of his era. Having risen to power and influence as a cleric at the court of Louis XVI, Talleyrand served in the Assemblée nationale following

FIGURE 1. Charles Percier (French, 1764–1838) and Alexandre Théodore Brongniart (French, 1739–1813). *Londonderry Vase* (*Vase étrusque à rouleaux*), 1813. Gilbert Drouet and Christophe Ferdinand Caron, decorators; Manufacture Nationale de Sèvres, manufacturer. Hard-paste porcelain with polychrome enamel decoration, gilding, and ormolu mounts; h. 137.2 cm. The Art Institute of Chicago, Harry and Maribel Blum Foundation, Harold L. Stewart Funds (1987.1). This monumental object was ordered by the restored Bourbon monarch Louis XVIII as a gift for Viscount Castlereagh, the second Marquis of Londonderry.

the Revolution. Subsequently, during the periods of the Directorate, the Consulate, and the Empire, he served Napoleon at different intervals as foreign minister, distinguishing himself in Europe by his brilliant and manipulative manner of diplomacy.

The Sèvres archives do not reveal for whom the vase was ultimately intended; Talleyrand was surely the agent of its disposition. It left the factory on July 2, 1814. In his 1937 publication, *Londonderry House and Its Pictures*, Harford Montgomery Hyde, archivist for the Londonderry estate, recorded a large vase in the boudoir and ante-drawing room which, according to family tradition, was a gift from Louis XVIII at the signing of the Peace of Paris on May 30, 1814. By placing these bits of evidence in the context of contemporary French history, one can propose a chain of events.

Against the background of turmoil over Napoleon's insatiable military conquests, the empire crashed abruptly when the emperor was deposed in 1814. Talleyrand's behind-the-scenes role in helping bring this about and paving the way for the restoration of the Bourbon monarchy of Louis XVIII is well known.[2] The European powers were, naturally, ill-disposed to France, which had overnight become the defeated underdog. The allies against France, each of whom had its own agenda, were eager to divide up the Napoleonic spoils. While the Peace of Paris, signed May 30, initiated the dissolution of the empire, it remained until the fall of that year, when all European powers convened at the Congress of Vienna, to arrive at the final terms for France. Two major figures in the negotiations throughout the period before the signing of the Peace of Paris through the completion of the agreements of the Congress were Talleyrand and the English Secretary for Foreign Affairs, Robert Viscount Castlereagh (1769–1822), eventually the second Marquis of Londonderry.

Castlereagh, admired for his frankness by Talleyrand, was an advocate of moderation and fairness in working out terms for France. He sought to mediate and conciliate, recognizing the need for retaining the confidence of all the participants through direct personal contacts with the various sovereigns and ministers. His goal was a peace that would bring about an equilibrium in Europe. He was wise enough to realize that defeat for France was adequate humiliation; for the allies to mete out punishments and further humiliations might ultimately have a more devastating effect on the balance of power in Europe and the preservation of a monarchical-aristocratic order. Therefore, through both correspondence and personal visits, Castlereagh and Talleyrand were in direct communication over many months, even before the restoration of Louis XVIII and the cessation of hostilities in the spring of 1814.

Talleyrand saw in Castlereagh his best opportunity to wield influence on one of the the four major powers: England, Prussia, Russia, and Austria. While both statesmen shrewdly and intelligently handled their respective positions throughout the negotiations, each achieved some of his desired goals. Yet, Talleyrand, ever the manipulator, underestimated Castlereagh's candor and simplicity, mistaking it for malleability. At times, the British minister vexed and confounded Talleyrand; yet, in one sense, they were important allies.

Throughout the eighteenth and early nineteenth centuries, the giving of

gifts and bribes by the defeated party was systematic and institutional in the working of politics. It was entirely common to give commemorative gifts to signers at the conclusion of peace treaties, as well, but usually these were on the scale of diamond-inlaid snuff boxes or formal orders. Talleyrand prevailed on Viscount Castlereagh to visit him in Paris in mid-August on the British minister's way to Vienna for the Congress, which was to convene in September. In their two days of meetings around August 20, Talleyrand sought the English diplomat's assurance that France would not be excluded from the negotiations and Castlereagh, in turn, received from Louis XVIII a pledge of cooperation. This must have been the moment that Talleyrand gave the great Sèvres vase to Castlereagh, since it was the only time the two met following the vase's shipment from the sale room and the meeting of the two diplomats later in Vienna. The amount of shipping charges recorded at Sèvres was relatively small and would not have been enough to send it to London or Vienna. No other Sèvres gifts were given at this time to any of the other participants. Usually gifts of this magnitude were sent from monarch to monarch, but this must have been a special, personal gift for Castlereagh, himself, from the French monarch, possibly as a token of his pledge.[3]

Still active today and located since 1756 in the Paris suburb of the same name, the famous Sèvres manufactory had its roots in a porcelain works begun, during the 1730s, in the old Château de Vincennes, also in the environs of Paris. While the earliest history of this factory is neither clearly nor well documented,[4] it is believed that disgruntled workers from the ceramics factory at Chantilly began the initial production, examples of which have yet to be identified. Indeed, a white, soft-paste porcelain was eventually successfully produced there; sales are consistently recorded after 1746.[5] It had been the desire of the Vincennes organizers, despite the fact that soft-paste porcelain was already being successfully produced at both Chantilly and St. Cloud, to manufacture a French product to compete with that of the great Saxon porcelain works at Meissen, Germany. It was in 1709 at Meissen that the first true hard-paste porcelain in Europe had been produced in imitation of the most sought-after Chinese porcelains brought to Europe during the seventeenth century. The factory flourished under the patronage of two monarchs, and Meissen porcelain could be found in royal courts and aristocratic circles throughout Europe. By the 1740s, it was being imported to France by the Parisian *marchands-merciers* (the guild of dealers in works of art, furniture, and luxury items for the furnishing of interiors) and made available for sale in their shops. It is no wonder that in France, long the style center of the Western world, entrepreneurs sought to take over the porcelain market from the Germans.

Although privately organized, the Vincennes factory referred to itself as a "Manufacture Royale" as early as 1740. It did receive a royal privilege or license from Louis XV, and it appears to have had some attention from Madame de Pompadour, official mistress to the king after 1745. In 1751, the king took a stronger interest in the factory and in 1753 became the major shareholder. Use of the royal cypher of interlaced L's as a factory mark was initiated. That year, an A was placed in the royal monogram and, subsequently, B for 1754, and so on. By 1759, the king had acquired all the

outstanding shares of the factory, which had been transferred in 1756 to a new site at Sèvres. Henceforth, it was to be known as the Manufacture Royale de Porcelaine. It was at this time that the factory of Vincennes/Sèvres became, like its Dresden counterpart, an enclave of royal patronage in the production of luxury goods with the financial support of the crown in order to extoll its power and prestige.

France claimed a long history of patronage of the arts in the service of glorifying the monarchy. François I (reigned 1515–47), for example, had established and added to his court through building programs, and this sort of achievement had been even more splendid in the France of Louis XIV (reigned 1643–1715). It was manifested principally in the expansion and furnishing of Versailles as well as other royal residences through the Gobelin manufactories which not only created every sort of decorative art but served to develop a national style. Thus, in the third quarter of the eighteenth century, Louis XV (reigned 1715–74) carried on the tradition of his forebears: his Manufacture Royale at Sèvres turned out a wealth of beautiful objects (see fig. 2) in which he took great personal interest. These also appealed to members of his court and the increasingly affluent new middle class. The Sèvres factory proved to be a fortuitous venture in the years following its acquisition. Sèvres porcelain became the rage among royal and aristocratic clients. The king became his own best customer, acquiring gifts not only for members of his own large family, mistresses, and courtiers, but for representatives of other governments—royal and princely families and their ambassadors and diplomats—all those with whom France could curry favor.

Royal patronage gave an economic boost to the factory, which flourished for years afterward. The market for the costly and beautiful porcelains of Sèvres was not limited to the French; indeed, Sèvres porcelain became the most fashionable and influential ceramic ware in Europe in the second half of the century, eclipsing its distinguished German competitor at Meissen. The Rococo forms and decorations so popular at mid-century continued in use until the Revolution, although as early as 1764, Neoclassical shapes and elements of decoration were introduced, and the two styles not infrequently comingled. Following the discovery in the Limoges district of France of kaolin, the white clay essential to the production of true, hard-paste porcelain, the factory initiated production of a hard-paste body in 1769. The two ceramic bodies were subsequently produced concurrently until the end of the century. Yet, despite the success of its porcelains, by the end of the 1770s the factory was in financial crisis, in part because other French factories had been granted royal licenses to inaugurate hard-paste porcelain production. The serious domestic competition that ensued, coupled with the substantial costs of such a labor-intensive material as soft-paste porcelain and the general state of the economy, fostered a steady economic decline.

With its fortunes plummeting in the 1780s, the factory was deeply in debt. At the outbreak of the Revolution, it was confiscated by the governing revolutionary Convention because it was crown property. The state-owned factory, burdened by debt and lacking royal subsidy provided in the past, required massive restructuring in order to succeed financially.

With the arrival of the new century and the new French social order, a decision was made to reorganize the factory. Napoleon's minister of the

interior, Lucien Buonaparte, appointed as director Alexandre Brongniart (1770–1847). That choice proved to be a brilliant one, as the young man brought to the position diverse expertise, managerial abilities, fiduciary talents, and an understanding of aesthetic concerns. The son of the French Neoclassical architect Alexandre Théodore Brongniart (1739–1813), the young Alexandre was educated as a scientist, had training as a mining engineer, and was knowledgeable in the fields of geology, mineralogy, and zoology. This broad familiarity with the natural and physical sciences enabled him to understand and improve the technological aspects of ceramic "engineering." Brongniart initiated various changes to cut costs: he halted the costly production of soft-paste porcelain and, in the hope of pursuing the fashionable taste for the antique style, he simplified or modified the eighteenth-century Rococo models. He lowered prices on existing wares and sold off outdated stock to raise capital. Furthermore, he hired someone with broad experience in Neoclassical design, someone in whom he had complete trust: his own father. The elder Brongniart was to provide designs for forms and decorations to be put into production at the factory; he also served as an advisor to his son. Two other important French cultural figures also wielded substantial influence: Dominique Vivant Denon (1747–1825) and Charles Percier (1764–1838). Denon, the diplomat/collector/ classicist, had accompanied the Napoleonic campaign in Egypt. During the Napoleonic wars, he played an important role in the routing of great masterpieces of art directly to Paris and may justly be considered responsible for the development of museums and collections in France through his position as director of the Musée Napoléon (the Louvre). His importance for Sèvres, through the advice and counsel he gave the young Brongniart as well as through the forms of the Egyptian and Greco-Roman ceramics he deposited at the manufactory, was substantial.

Also of inestimable influence was architect Charles Percier who, along with his colleague Pierre François Léonard Fontaine (1762–1853), may be considered the patriarch of the French Empire style. Their publications of antiquities and their *Recueil des décorations intérieures*, first published in 1801, provided artists and craftsmen in all fields with a visual vocabulary of classical forms.

The young Brongniart's technical, procedural, and economic changes did not immediately put the factory on firm economic footing. Indeed, it was probably the shrewd judgment of Napoleon himself, named emperor in 1804, who realized that, like his predecessors from the *ancien régime*, he would require splendid imperial fittings for his palaces as well as gifts for his foreign courts. Thus, in 1806, the emperor added the Sèvres manufactory to his Civil List, those institutions awarded subsidies by the state. This infusion of capital by the emperor into the reorganized porcelain factory finally assured its economic success.

The notion of an enormous, monumental vase had been introduced at Sèvres in the eighteenth century. Such a venture could have been undertaken only following the introduction of hard-paste porcelain. In 1783/84, the two largest vases ever made at Sèvres, conceived by Louis Simon Boizot (director, 1775–80) and with mounts by Pierre Philippe Thomire (1751–1843), were completed. One is now in the Musée du Louvre, the other in the Palazzo Pitti

FIGURE 2. Model attributed to Jean Claude Duplessis the Elder (French, act. 1747–74). *Vase à éléphants*, 1757. Manufacture Nationale de Sèvres, manufacturer. Soft-paste porcelain, rose pompadour, polychrome enamel decoration, and gilding; h. 39.2 cm. The Art Institute of Chicago, The Joseph and Theresa Maier Memorial, Gift of Kenneth J. Maier, M.D. (1986.3446). Objects such as this vase, produced at the royal manufactory under Louis XV, appealed to the members of the court and the increasingly affluent new middle class.

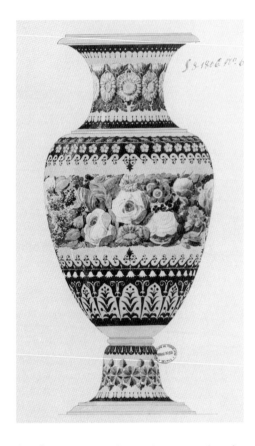

FIGURE 4. Alexandre Théodore Brongniart. *Design for "Vase floréal,"* 1806. Watercolor and ink on paper. Sèvres Manufacture Nationale de Sèvres.

FIGURE 3. Alexandre Théodore Brongniart. *Design for Elements of Decoration for "Vase étrusque à rouleaux,"* 1810. Ink and watercolor on paper. Sèvres, Manufacture Nationale de Sèvres archives.

in Florence. Another pair was made a few years later; the rest belong to the first half of the nineteenth century. In many instances, as with the *Londonderry Vase*, we know from the registers that the monumental vases were the largest of several sizes in which the same decorative scheme was used. As the documents reflect, these huge examples were costly and for the most part were royal or imperial gifts.

The 225 designs for porcelain that the elder Brongniart supplied to the factory following his appointment in 1801 still exist today in its archives. They serve not only as remarkable documents in themselves, but, taken in concert, they reveal the evolution of forms and style of decoration from the Consular period well into the Empire period. Among them is the original design for the *Londonderry Vase*, dated 1810. The precise rendering in ink and watercolor on paper shows one-half of the symmetrical design (fig. 3). High on the right side of the sheet, inscribed in crayon, are suggestions for optional treatment:

> Instead of flowers and fruits in the fillet that supports the bird, it is not necessary that the foliage on them be in the Greek style. The little flowers are to be in proportion with flowers on the garland.[6]

In comparing the completed Art Institute vase with the original 1810 scheme, one notes that generally the two are close except for the flower decoration around the center. It is considerably altered from the thin garland in the drawing. Indeed, the actual wide band of full-blown natural flowers is much more closely related to those shown in a design for the elder

Brongniart's *Vase floréal*, dated 1806 (fig. 4).[7] This also suggests that at Sèvres, as is often the case in other disciplines in the decorative arts, designs were not slavishly copied by the artists who carried out the schemes.

What is fascinating about the Brongniart design for the *Vase étrusque à rouleaux* is the fact that precisely the same elements may be found in an engraved plate of Percier's and Fontaine's *Recueil des décorations intérieures*

FIGURE 5. Charles Percier and Pierre François Léonard Fontaine (French, 1762–1853). *Recueil des décorations intérieures* (Paris, 1801), illustration for *Boudoir of Madame M.* executed in Paris.

FIGURE 6. Detail of fig. 5.

FIGURE 7a–b. Details of fig. 1.

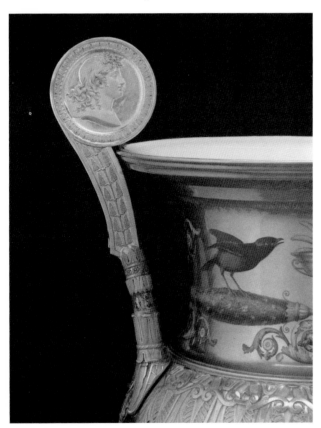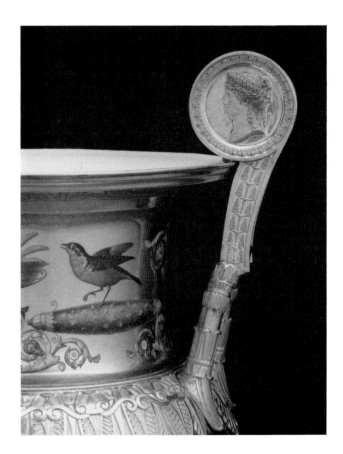

(fig. 5). In the border of the engraving, there are on either side of the center roundel small, elongated, flower-sprigged elements which have small attachments at either end (fig. 6). A nearly identical, grass-green, flower-sprigged element appears on the collar or neck of the museum's vase under each bird (fig. 7a-b). The birds, too, are similar in form and spirit to those shown in the engraved border (fig. 8). The Etruscan-style scrollwork in the margins also bears an affinity with the polychrome scrollwork on the vase. Lastly, the portrait medallions on either scroll handle—one male, one female—call to mind those in the engraving. Curiously, no record has been found in the Sèvres archives that identifies the profile portraits on the scroll handles by subject or modeler. Neither do they appear on the Brongniart design. While it has been suggested that they may portray Louis XVIII and Marie Louise, it seems more plausible that they were simply adapted from the antique. In *Recueil des décorations intérieures*, vase no. 1 in plate 54 (fig. 9) is identical in configuration to that of the elder Brongniart, including the pair of profile masks in the scroll handles, although the decorative scheme differs. While the records and drawings in the Sèvres archives show that Alexandre Théodore Brongniart produced the designs for the Chicago vase, the relationship of very specific elements from Percier and Fontaine that reappear in Brongniart's scheme is convincing evidence that Brongniart was absorbing and adapting the Neoclassical vocabulary so widely promulgated by the two arbiters of the style. Yet, though the publication illustrates this general form, it was Charles Percier who created the shape of the vase itself in 1805.[8] He, in turn, based his design on the South Italian form of the volute krater (see fig. 10) which was well known from examples in Vivant Denon's collection deposited at Sèvres.

The day books, or daily production records, which also survive, list separate costs for each of the different artisans in their specialty in the production of a single form. In this "piecework" record, the total costs of production and subsequent sale price of the finished object are recorded. Because pieces of Sèvres porcelain are marked and we know the years during which specific marks were used at the factory, we can correlate specific works with the register documentation. Thus, we can glean substantial information about the Art Institute's vase. It is stamped with the crowned eagle mark of the Manufacture Imperiale/Sèvres, located inside the neck (fig. 11). It also bears two inscriptions: one in gold, *30 Mars B.T.* and below it in red—*Drouet/1813* (fig. 12).

These marks establish that the vase was produced between 1813 and 1815, the years the crowned eagle mark was used. The *B.T.* mark, written in gilding, is the monogram of the gilder, Charles Marie Pierre Boitel (act. 1797–1822), and *Drouet* refers to the well-known Sèvres painter of flowers Gilbert Drouet (act. 1785–1825). The date 1813 indicates the year the flower painting was executed. While the marks reveal *some* information, they by no means begin to reveal the complete roster of collaborators and processes

FIGURE 8. Detail of fig. 5.

FIGURE 9. Charles Percier and Pierre François Léonard Fontaine. *Recueil des décorations intérieures* (Paris, 1801), illustration for vase no. 1, pl. 54.

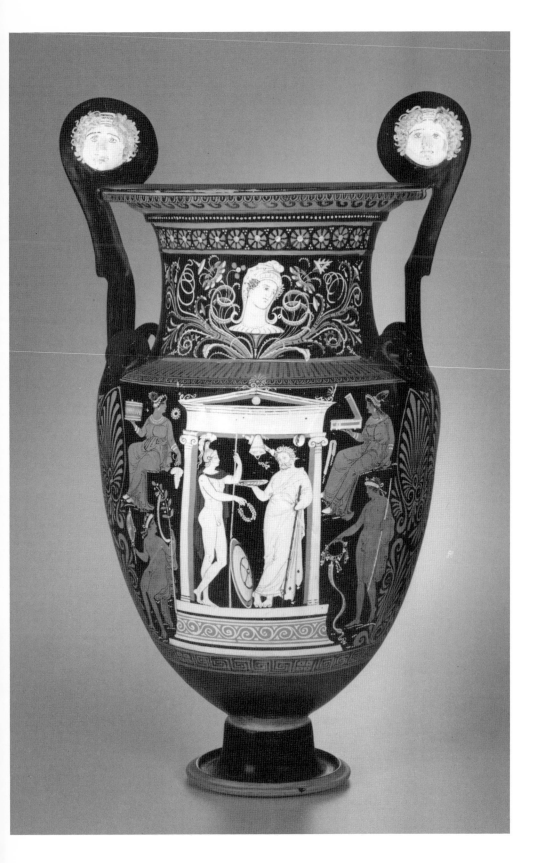

FIGURE 10. Southern Italy
(Apulia). *Volute Krater*,
325–308 B.C. Terracotta;
83 cm. The Art Institute of
Chicago, Katherine K. Adler
Fund (1984.8). Vases of this
sort were illustrated by
Percier and Fontaine in the
*Receuil des décorations inté-
rieures*, and served as the
basis for Percier's design for
the shape of the *London-
derry Vase*.

FIGURE 11. Detail of fig. 1 showing the crowned eagle mark, stamped in red, of the Manufacture Imperiale/Sèvres, manufactory date mark used between 1813 and 1815. Manufacture Nationale de Sèvres archives. This manufactory date mark establishes that the vase was produced between 1813 and 1815.

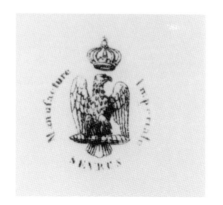

FIGURE 12. Manufacture Imperiale/ Sèvres, gilder's monogram, 1813. Manufacture Nationale de Sèvres archives. The upper inscription in gold is that of the gilder, Boitel; below is the signature of the flower painter, Drouet.

involved in the creation of this great vase. The Sèvres archives provide further information. The date 1813 leads one to the dated *feuille d'appréciation* (valuation sheet made for each of the completed pieces entering the factory sale room). The *Londonderry Vase* entered the sale room on December 9, 1813, and is precisely described on sheet 54 as an "Etruscan cylindrical vase, scroll handles, ground of gold, laminated ornament of gold relief burnished for effect, life-sized natural flowers, ornaments around and colorful birds" (fig. 13). Below the description, various piecework costs are itemized:

> The porcelain body, 2,000 francs; the gold ground, 100 francs; relief gilding, 123 francs; gold, 372 francs; painter of ornaments, birds by M. Caron, 296 francs; painter of flowers and ornaments by M. Drouet, 2,400 francs; burnishing, 160 francs and 233 francs; total direct costs, 5,686 francs; additional costs, 2,823 francs; bronze mounts, 2,948 francs; price of manufacture, 11,311 francs. Sale price, 22,000.[9]

Mme Tamara Préaud, the indefatigable archivist at the Sèvres manufactory, has recently suggested that the enormous difference between the costly manufacturing price and the sale price indicates that vase was of exceptional merit.[10]

In delving into additional Sèvres records, Mme Préaud has been able to find documents that elucidate further the itemizing of costs in the *feuille* with the names of other individuals who worked on facets of production. The M. Caron referred to in the cost-accounting of the vase was Christophe Ferdinand Caron (act. 1782–1815), a Sèvres painter specializing in birds and animals, in this instance, the four birds of different species based on actual specimens. The gilder Boitel worked on the foot of the vase with the ivy border and the two handles in July; in August, he worked on the collar.[11] In September, the gilder M. Durosay worked on the same elements.[12] In June, Mlle Le Grand, a burnisher, worked on the collar, roughening around the birds and ornaments; in August, she is recorded as noting (no longer visible) on one of the border edges, in crayon, that the work was begun on July 20 and completed on August 11.[13] In June, M. Capronier, a gilder, worked on the handles.[14] The chiseler, gilder, and mount-maker M. De la Fontaine worked

FIGURE 13. *Feuille d'appréciation* (valuation sheet) for the production of the *Vase étrusque à rouleaux*, dated December 9, 1813, when the vase was first exhibited in the Sèvres showrooms. Manufacture Nationale de Sèvres archives.

on the main section of the body, the collar, and the two handles as well as the foot.[15] Mme Troyon, a burnisher, worked on the two handles, collar, and foot from August to November 1813.[16] Mme Mascret, another burnisher, spent eighteen working days burnishing all the gold ground; when finished, she inscribed the margin (no longer visible) with the dates of beginning and completion; subsequently, she further burnished the gold ground, the handles, the collar, and body of the vase in August, September, and November.[17]

Many Sèvres Empire-style vases, particularly the more monumental, large-scale examples, integrate specific portraits or history paintings into their scheme of decoration. In shape and decoration, these vases have an imperial, formal quality. The vases encircled by lush garlands have quite a different

visual effect. The rigid, formal vase shape contrasts with the languid, natural beauty of a mass of trompe l'oeil flowers cleverly twisted around a golden rope—nature intruding upon an artificial world. This natural flower decoration echoes that of the *ancien régime*, as it was the most characteristic decorative mode of eighteenth-century Sèvres. The flowers, the birds that appear to have just alighted, and the thoroughly realistic butterfly were transcribed directly from nature. It is in these great, Empire works of Sèvres that one sees reflected the ideas of verity and empirical observation, as scientifically transmitted through botanical, entymological, and ornithological treatises. The young Brongniart, referring to his father's *Vase floréal* of 1806, wrote: "It is good that the subject of flowers which makes the manufacturer's colors true is not abandoned altogether. I have preferred having made the grand vases in this subject because they can be used a lot more easily than painting."[18]

The flower-and-bird-bedecked *Londonderry Vase* was certainly more "useful," in the words of Brongniart, as a royal gift. One can only speculate that the French donors took into consideration the traditional love of flowers so often ascribed to the English when ordering the diplomat's present. A Sèvres vase depicting images of Napoleon or an 1813 example replicating the painting of 1798 by Achille Joseph Etienne Valois, *The Triumphal Arrival of Art from the Vatican in Paris* (fig. 14), would have been inappropriate because of their subjects. In the end, the greatest irony is the fact that the *Londonderry Vase*, one of the most splendid Empire objects produced in the imperial factory at Sèvres, and so closely associated with the whole of Napoleonic material culture, served to cement a relationship by two of the emperor's most formidable foes.

FIGURE 14. *Vase étrusque à rouleaux*, 1813. Hard-paste porcelain; h. 120 cm. Sèvres, Musée National de Céramique. The main body of the vessel is decorated with a reproduction of the painting by Achille Joseph Etienne Valois (French, 1785–1862). *The Triumphal Arrival of Art from the Vatican in Paris, 1798*. Certainly, this work, made at the same time as the Art Institute's *Londonderry Vase* and celebrating the victory of Napoleonic forces in Italy, was not an appropriate gift to the leading English diplomat in the weeks before the Congress of Vienna where the defeated French nation's fate was to be determined.

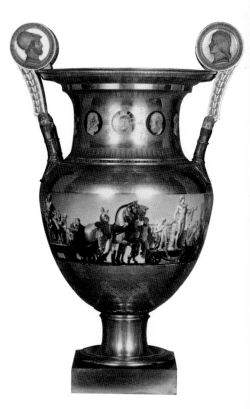

NOTES

Warner, "The Sources and Meaning of Reynolds's *Lady Sarah Bunbury Sacrificing to the Graces*," pp. 7–19.

I would like to thank Nicholas Penny and Desmond Shawe-Taylor for encouraging me and graciously sharing ideas and information with me as I wrote this article. Its starting-point was provided by David Mannings, who first noticed that Reynolds used Montfaucon for the tripod at which Lady Sarah performs her sacrifice (see note 5).

1. Sir Joshua Reynolds, "Discourse VI," *Discourses on Art*, ed. Robert Wark (New Haven and London, 1975), pp. 106–107.

2. See John Newman, "Reynolds and Hone. 'The Conjuror' Unmasked," in London, Royal Academy of Arts, *Reynolds*, exh. cat., ed. Nicholas Penny (1986), pp. 344–54.

3. The marriage ended in 1769, when Lady Sarah eloped with her cousin Lord William Gordon, after having given birth to an illegitimate daughter. She and Gordon parted but she remained separated from Bunbury, in spite of his willingness to forgive her and take her back, and a divorce was granted by the House of Lords in 1776. In 1781 she was married again, to Colonel the Hon. George Napier, by whom she had eight children, three of whom became famous generals in the British army. Mrs. Thrale remarked cattily that she "never *did* sacrifice to the Graces; her face was gloriously handsome, but she used to play cricket and eat beefsteaks on the Steyne at Brighton" (H. L. Piozzi [formerly Thrale], *Autobiography, Letters and Literary Remains*, ed. A. Hayward, 2nd ed., [1861], vol. 2, p. 173n.).

4. C. R. Leslie and Tom Taylor, *Life and Times of Sir Joshua Reynolds* (London, 1865), vol. I, p. 247.

5. See Frederick J. Cummings's entry on the work in The Detroit Institute of Arts and Philadelphia Museum of Art, *Romantic Art in Britain: Paintings and Drawings 1760–1860*, exh. cat. (1968), pp. 39–40; and David Mannings's in Royal Academy of Arts (note 2), pp. 224–25.

6. Royal Academy of Arts (note 2), p. 226.

7. Reynolds (note 1), p. 107.

8. See Francis Haskell and Nicholas Penny, *Taste and the Antique* (New Haven and London, 1981), pp. 43–44.

9. Bernard de Montfaucon, *Antiquity explained, and represented in sculptures*, trans. David Humphreys (London, 1721–22 and 1725), vol. 1, p. 108.

10. Bellori provided texts for a number of books of engravings after classical remains, but the present author has been unable to find his commentary on the relief in question.

11. See Erwin Panofsky, *Studies in Iconology. Humanistic Themes in the Art of the Renaissance* (New York, 1972), pp. 168–69; and Edgar Wind, *Pagan Mysteries in the Renaissance*, 2nd ed. (London, 1968), pp. 36–43, 73–75.

12. Montfaucon (note 9).

13. Reynolds (note 1), p. 107.

14. Robert Rosenblum, "Reynolds in an International Milieu," Royal Academy of Arts (note 2), pp. 48–49.

15. See *Letters Written by the Earl of Chesterfield to his Son, Philip Stanhope*, 2 vols. (London, 1774), passim.

16. On the interpretation and restoration of the group, see Sylvie Pressouyre, "Les Trois Grâces Borghese du Musée du Louvre. Un Groupe antique restauré par Nicolas Cordier en 1609," *Gazette des beaux-arts*, sér. 6, 71 (Mar. 1968), pp. 147–60.

17. See Detroit and Philadelphia (note 5), p. 40; and London, Royal Academy of Arts (note 2), p. 224.

18. Montfaucon (note 9), vol. 2, p. 95.

19. Ibid., pp. 85–86.

20. Ibid., p. 87.

21. See Royal Academy of Arts (note 2), p. 224.

22. Dublin, National Gallery of Ireland; repr. in Royal Academy of Arts (note 2), p. 20.

23. Edward Edwards, *Anecdotes of Painters* (London, 1808), p. 189.

24. Reynolds "Discourse V" (note 1), p. 78.

25. See Panofsky (note 11) and Wind (note 11).

26. Antoine Banier, *The Mythology and Fables of the Ancients, Explain'd from History* (London, 1739–40), vol. 2, p. 348.

27. Montfaucon (note 9), vol. 1, p. 107.

28. Banier (note 26), vol. 2, p. 350.

29. Ibid., p. 353.

30. See Wind (note 11), pp. 26–35.

31. Banier (note 26), vol. 2, p. 354.

Bandiera, "Form and Meaning in Hubert Robert's Ruin Caprices: Four Paintings of Fictive Ruins for the Château de Méréville," pp. 21–37.

The author wishes to express his gratitude to Katherine Kotner, who will always be his inspiration.

1. For an overview of French eighteenth-century ruin painting, see M. Roland-Michel, "De L'Illusion à l'inquiétante étrangeté: quelques remarques sur l'evolution de sentiment et de la représentation de la ruine chez les artistes français à partir de 1730," in Académie de France à Rome, *Piranèse et les français*, exh. cat., ed. G. Brunel (Rome, 1978), pp. 475–98. See also R. Jullian, "Le Thème des ruines dans la peinture de l'époque néo-classique en France," *Bulletin de la Société de l'Histoire de l'Art Français*, 1976, pp. 261–72. For further insights into major themes in French ruin painting as well as its relationship to the literary treatment of ruins, see R. Rosenblum, *Transformations in*

Late Eighteenth Century Art (Princeton, N.J., 1967), pp. 107–45; and R. Mortier, *La Poétique des ruines en France* (Geneva, 1974).

2. The Robert bibliography is very large. The standard monograph is P. de Nolhac, *Hubert Robert* (Paris, 1910). Another excellent general source is C. Gabillot, *Hubert Robert et son Temps* (Paris, 1895). For specific aspects of Robert's art, see B. De Montgolfier, "Hubert Robert Peintre de Paris au Musée Carnavalet," *Bulletin du Musée Carnavalet* 17 (1964), pp. 2–35; H. Bürda, *Die Ruine in den Bildern Hubert Roberts* (Munich, 1967); and Paris, Musée du Louvre, *Le Louvre de Hubert Robert* (Paris, 1979). For Robert's drawings, see de Nolhac and G. K. Loukomski, *La Rome d'Hubert Robert* (Paris, 1930); M. Beau, *La Collection des dessins d'Hubert Robert au Musée de Valence* (Lyon, 1968); Washington, D.C., National Gallery of Art, *Hubert Robert, Drawings and Watercolors*, exh. cat., ed. V. Carlson (1978).

3. *The Obelisk* is signed and dated on the pedestal of the column to the left: *H. Robert 1787. The Landing Place* is signed and dated: *H. Robert in aedibus merevillae pro d. delaborde pinxit A.D. 1788.* All the paintings were removed in the nineteenth century and sold at auction in 1900 (see M. L. François sale, Paris, Galerie Georges Petit, June 13, 1900, nos. 1–4). They were acquired by The Art Institute of Chicago in that same year. The four paintings are mentioned by de Nolhac (note 2), pp. 153–54 and nos. 1–4. See also T. Leclère, *Hubert Robert et les paysagistes français du XVIIIᵉ siècle* (Paris, 1913), p. 92; The Art Institute of Chicago, *Paintings in the Art Institute of Chicago* (1961), pp. 401–402; J. Maxon, *The Art Institute of Chicago* (New York, 1970; reprint 1977, 1983, 1987), pp. 61–63; and The Art Institute of Chicago, *Selected Works of Eighteenth Century French Art in the Collections of The Art Institute of Chicago*, exh. cat., ed. Susan Wise (1976), pp. 24–25.

4. The Marquis de Laborde acquired his estate at Méréville in 1784. The first chief garden designer was François Joseph Belanger (1744–1818), who is best known as the creator of the Folie Saint James at Neuilly. In a letter of May 1786, Robert indicated that, up to that point, he had no first-hand knowledge of the project. Shortly thereafter, however, he took over from Belanger as chief garden designer. For a history of the garden at Méréville and more information on Robert's contribution to the project, see C. Bernois, *Histoire de Méréville* (Paris, 1968); O. C. de Janvry, "Méréville," *L'Oeil* 180 (Dec. 1969), pp. 30–41, 83, 96; W. H. Adams, *The French Garden: 1500–1800* (New York, 1979), pp. 129–38; and R. A. Etlin, *The Architecture of Death: Transformation of the Cemetery in Eighteenth-Century Paris* (Cambridge, Mass., 1984), pp. 224–26.

5. Robert was received into the Royal Academy on July 26, 1766. His *morceau de réception* (presentation piece) was a caprice view of the Porta di Ripetta in Rome surmounted by the Pantheon (Paris, Ecole des Beaux-Arts). For his achievement as a garden designer, see Gabillot (note 2), ch. 10 ; E. de Ganay, *Les Jardins de France et leurs décors* (Paris, 1949); J. Langner, "Architecture pastorale sous Louis XVI," *Art de France: Revue annuelle de l'art ancien et moderne* 3, (1963), pp. 171–86; Bernois (note 4); and de Janvry (note 4).

6. There is also a work almost identical to *The Fountains* entitled *Ruins with Washerwomen* in the collection of the Duchesse d'Uzés (see Bürda [note 2], fig. 27).

7. See below, note 26.

8. There can be no doubt that Robert personally knew Piranesi (whose workshop was located on the via del Corso directly opposite the Académie de France). He also owned a number of works by Piranesi. For a discussion of Robert's connections with Piranesi, see Bürda (note 2), pp. 43–48; and Académie de France à Rome, *Piranèse et les français: 1740–1790*, exh. cat. (1976), pp. 304–26.

9. Most "romantic" French gardens were conceived in this way. The term *pays d'illusions* (land of illusions) originated with Louis de Carmontelle, the designer of Parc Monceau. The exact quotation, which follows, is also revelatory as to the eighteenth-century attitude vis-à-vis the relationship of painting and garden design: "Si l'on peut faire d'un Jardin pittoresque un pays d'illusions, pourquoi s'y refuser? On ne s'amuse que d'illusions, si la liberté les guide, que l'Art les dirige. . . . Transportons, dans nos Jardins, les changements de scène de l'Opéra; faisons-y voir, en réalité, ce que les plus habiles Peintres porroient y offrir en décorations, tous les temps et tous les lieux." (If one can make of the picturesque garden a land of illusions, why refuse to do so? One cannot help but be charmed by illusions if they are guided by freedom, directed by art. . . . Let us bring to our gardens the changing sets of the opera; let us see there, in reality, what the most able painters could offer as decoration, all times and all places.)

10. The influence of Piranesi upon the French school of architectural fantasists was the focus of a scholarly conference in Rome. The resulting publications are the best source of information on this subject. See Académie de France à Rome, *Piranèse et les français*, exh. cat. (note 8); and Académie de France à Rome (note 1).

11. This was also noted by Robert's contemporaries. Charles Joseph Natoire, the director of the Académie de France à Rome, in a letter of February 28, 1759, wrote, "C'est un bon sujet qui travaille avec une ardeur infinie. Il est dans le genre de Jean-Paul Pannini." (He [Robert] is a good pupil who works with constant ardor. He works in the genre of Giovanni Paolo Pannini) (cited in Gabillot [note 2], p. 74.) For more information on Pannini's influence on Robert during his formative years, see P. de Nolhac, "Les Premières oeuvres Romaines d'Hubert Robert," *La Rennaissance de l'art française* (Jan. 1923), pp. 231–49.

12. Cited in The Detroit Institute of Arts and New York, The Metropolitan Museum of Art, *French Painting 1774–1830: The Age of Revolution*, exh. cat. (Detroit, 1975), p. 589. Robert's art collection, sold after his death in 1808, contained approximately thirty works by Pannini. For Robert's art collecting, see Gabillot (note 2), pp. 248, 256.

13. For Lemaire, see A. Blunt, "Jean Lemaire Painter of Architectural Fantasies," *The Burlington Magazine* 83, 487 (1943), pp. 241–46.

14. W. L. Barcham, "The Imaginary View Scenes of Antonio Canaletto" (Ph.D. diss., Institute of Fine Arts, New York University, 1974), p. 45.

15. In Rosenblum (note 1), p. 113.

16. For Servandoni as a painter, see J. Bouché, "Servandoni," *Gazette des beaux-arts*, sér. 4, 4 (Jul.–Dec., 1910), pp. 121–46;

H. de Chennevières, "Jean-Nicolas Servandoni peintre, architecte, décorateur et machiniste, ordonnateur de fêtes publiques," *Revue des arts décoratifs* (1880–81), vol. I, pp. 429–35; Marie-Louise Bataille in Dimier, *Les Peintres francais du XVIIIᵉ siècle* (Paris, 1930), vol. 2, pp. 379–92; C. di Matteo, *Servandoni décorateur d'opéra* (mémoire de maîtrise, University of Paris, 1970); M. Roland-Michel, "De Pannini à Servandoni ou la réattribution d'un tableau de Musée des Beaux-Arts," *Bulletin des musées et monuments Lyonnais* 6, 2 (1977). Very little scholarly attention has been paid to de Machy, considering his importance as a ruin painter and chronicler of the Parisian scene. The only monographic treatment is S. Bouchery, *Essai sur Pierre Antoine De Machy* (Positions des Thèses du Louvre, 1948). See also B. de Montgolfier, "La Démolition de l'Eglise des Saints Innocents vue par De Machy," *Bulletin du Musée Carnavalet* 25 (June 1972), pp. 21–34; and Roland-Michel, "The Clearance of the Colonnade of the Louvre: A Study Arising from a Painting by De Machy," *The Burlington Magazine* 120 (Sept. 1978), pp. i–vi.

17. Anatole de Montaiglon, ed., *Procès verbaux de l'Académie royale de peinture et de sculpture* (Paris, 1875–92), vol. 5 (1731), p. 87.

18. De Machy was received into the Académie on Sept. 30, 1758 as "Peintre d'architecture" (see de Montaiglon [note 17], vol. 7, p. 73). He gave as his reception piece a painting representing, "des ruines d'architecture" (architectural ruins). This is probably the painting illustrated here (fig. 14), as indicated by the scholarly consensus: see Bouchery [note 16], p. 17; Roland-Michel in Académie de France à Rome, *Piranèse et les français*, exh. cat. (note 8), pp. 115–18.

19. Rousseau is an obscure figure, and there are only a handful of works known to be by his hand. As a specialist in architectural perspectives, he worked at Marly and Versailles and at Hampton Court after around 1688.

20. The four paintings in this series are *The Interior of the Temple of Diana at Nîmes*; *The Pont du Gard*; *The Maison Carrée, The Arenas and the Tour Magne of Nîmes*; and *The Triumphal Arch and Amphitheater at Orange and the Monument and Small Arch at Saint Rémy* (fig. 17). The first two are straightforward views, and the second two are topographical caprices. The liberties taken by Robert in his capricious grouping of monuments were viewed unfavorably by critics, among them the critic Louis Petit de Bachaumont, who wrote in *Mémoires Secrets*, ". . . un assemblage idéal d'èdifices disparates qui n'ont jamais existé ensemble, bizarrerie révoltante pour le spectateur chez qui c'est supposer trop d'ignorance; M. Robert inventif rempli de ressources dans son art pour vouloir être original, pêche souvent contre le bon goût et le bon sens." (. . . an imaginary grouping of disparate buildings that never stood together, a revolting bizarre spectacle for the viewer of whom too much ignorance is presumed; the inventive Mister Robert who goes to great ends in his art in order to be original, often sins against good taste and common sense.) The pictures were also unfavorably received by the Direction des Bâtiments which returned two of them to Robert. Though the exact reason is not known, it is probably because they were considered insufficiently decorative. For a discussion of this project, see Washington, D.C., National Gallery of Art, *The Eye of Thomas Jefferson*, exh. cat. (Washington, D.C., 1976), p. 95.

21. The Marquis de Laborde shared Robert's interest in the antiquities of France. He began, and never completed, a *Voyage pittoresque de la France*, and began his *Monuments de la France* after 1780.

22. The first great archeological study of the Roman monuments of Provence was C. L. Clérisseau, *Antiquités de la France* (Paris, 1778). In March 1763, the Académie royale d'architecture honored the Comte de Caylus for his efforts to compile a volume of views of the ancient monuments of Languedoc and Provence. It should also be noted that Robert traveled to Provence, where he did detailed studies of the antiquities.

23. The Tomb of Captain Cook and the Rostral Column are thematically related. In 1786, two of the Marquis de Laborde's sons, aged twenty and twenty-four, perished in the voyage with La Pérouse as they followed the path of Captain Cook. For these structures, see de Janvry (note 4), pp. 34 (ill.), 83; and Etlin (note 4).

24. Robert treated the temple in a similarly fractured and overgrown manner in an actual garden setting when he designed the *Temple de la philosophie moderne* at Ermenville for the Marquis René de Girardin. This structure was also meant to symbolize the continuity of time, as Robert Rosenblum has stated, "In the *Temple* at Erenonville, however, the sad spectacle of the works of man slowly being absorbed by the organic forces of nature produced a remarkable Romantic conceit. The six standing columns are each dedicated to a famous modern philosopher . . . whereas the three remaining columns that would complete this peripteral temple lie on the ground, presumably waiting to be revived by the great philosophers of the future" (Rosenblum [note 1], pp. 116–17).

25. C. F. Volney, *Les Ruines, ou méditations sur les révolutions des empires* (1826 ed.), p. 4.

26. Denis Diderot, *Salons*, comp. J. Seznec and J. Adhémar (Oxford, 1963), vol. 3, pp. 228–29. For a thorough discussion of Diderot's attitude toward ruins, see Mortier (note 1), pp. 88–106. Robert's works also inspired the critic Mayrobert in 1773 to contemplate the inescapability of death: "Aussi qu'est-on attristé en voyant les ouvrages de celui-ce, qui nous remet, sans cesse sous les yeux les monuments dégradés de l'ancienne Rome, et nous atteste trop bien que rien ne résiste au temps déstructeur." (One is also saddened by the sight of the works of this man [Robert], who unceasingly places before our eyes monuments of ancient Rome in ruins, and bears witness too well to us that nothing can resist the destructive effects of time.) (cited in Gabillot [note 2], p. 117.)

27. Cited in Mortier (note 1), p. 92. Similar sentiments were expressed some years later by Viscomte François René de Chateaubriand who, in his *Génie de Christianisme* (1802), wrote, "Les ruines considérées sous les rapports pittoresques, sont d'une ordonnance plus magique dans un tableau, que les monuments frais et entiers." (Ruins in a picturesque context have a more magical appearance in a painting then do new and intact monuments) (cited in Mortier [note 1], p. 171.)

28. For the most thorough discussion of this work and other versions of the same subject, as well as their pendants, see Paris (note 2).

29. Although it is characteristic of Robert's romantic attitude that national pride and optimism are counterbalanced by melancholy, his use of pendants in this way—a building not yet completed with the same building in ruins—is unique in his art. This may indicate his disaffection from the politically charged atmosphere surrounding this project to convert the royal picture galleries to a public museum. Robert suggested that the efforts of the post-revolutionary administrators to emulate the grandeur of the *ancien régime* for their own political ends were vainglorious. Their monuments were as subject to the laws of time and nature as those erected by kings.

30. For a thorough discussion of the response of eighteenth-century writers to "ruines fabriqués (fabricated ruins), see Mortier (note 1), pp. 107–35.

Wardropper and Rowlands, "Antonio Canova and Quatremère de Quincy: The Gift of Friendship," pp. 39–46.

The authors would like to express their appreciation to Profs. Drs. Hans Körner and Friedrich Piel for the information concerning the Jacques Louis David portrait of Quatremère de Quincy. The information is published in " 'A mon ami A. Quatremère de Quincy' Ein unbekanntes Werk Jacques-Louis Davids aus dem Jahre 1779," *Pantheon* 43 (1987), p. 80. They would also like to thank Sergey Androssov, Curator of Sculpture, The Hermitage Museum, for the photograph of *Paris* (see fig. 6).

1. There are three works after Canova in the Art Institute's collection. The most interesting is a marble relief, *The Lamentation of Christ* (1966.130), executed by Canova's principal studio assistant, Antonio d'Este, after a model by Canova in 1800 on commission for Count Widman of Venice. See Elena Bassi, *La Gipsoteca di Possagno: Sculture e dipinti di Antonio Canova* (Venice, 1957), p. 150. The second is a plaster of the large self-portrait by Canova (1975.203), but its quality is mediocre and it may be an after-cast rather than a workshop version. The last is a bronze statuette after Canova's monumental *Hercules and Lichas* (1977.525), probably cast by Francesco Righetti, c. 1810/20. See Ian Wardropper in The Art Institute of Chicago, *A Decade of Decorative Arts: The Antiquarian Society of The Art Institute of Chicago*, no. 20 (Chicago, 1986), p. 32.

2. For the versions of the full-length statue of Paris, see G. Pavanello, *L'opera completa del Canova* (Milan, 1976), nos. 205–209.

3. Melchior Misirini, *Della vita di Antonio Canova* (Prato, 1824), p. 508, gave the date of the bust for Monsieur Alquier as 1808, thus earlier than for the one given to Quatremère. But he also dated the latter as 1814, rather than the correct date of 1809, so his information is at least questionable.

4. For the busts in Leningrad, Munich, Copenhagen, and East Berlin, see Pavanello (note 2), nos. 207, 208. For the busts in Rome, see A. Riccoboni, *Roma nell'Arte* (Rome, 1942), pp. 338–39.

5. Pavanello (note 2), no. 207, identified the Hermitage bust as probably that belonging to Quatremère.

6. *Catalogue d'objets d'art, antiquités, égyptiennes, grecques et romains, vases grecques, terre cuites, figurines en bronze, sculpture en marbre, dont deux beaux bustes de Canova, médailles, miniatures, dessins et belles estampes anciennes et modernes, composant le cabinet de feu M. Quatremère de Quincy, . . . dont la vente aura lieu le lundi 22 avril 1850* (Paris, 1850), no. 2, p. 3. The entry reads: "Le berger Paris, buste en marbre. Ce beau morceau de sculpture, pour lequel Canova s'est inspiré des artistes grecs, et où la noblesse et la pureté du style sont joint à la plus parfaite exécution, justifie l'importance que lui-même y attachait en en faisant don d'amitié à M. Quatremère, pour lequel il l'avait exécuté. Ce que nous indique la dédicace suivante: Antonio Quatremere Amico Optimo, Antonius Canova dono dedit, F. Romae, anno 1809. h. 54, socle 16." (The shepherd Paris, marble bust. This beautiful piece of sculpture, for which Canova was inspired by Greek artists, and in which nobility and purity of style are joined to the most perfect execution, justifies the importance which he attached to it in making it a gift of friendship to M. Quatremère, for whom he made it. This is indicated to us by the following dedication [etc.]. . . .)

7. The Chicago *Bust of Paris* also appeared at auction in Paris at the Hôtel des Ventes Mobilières, rue des Jeuneurs, no. 42, *Catalogue d'une collection d'objets d'art et de curiosité . . .* , Mar. 15, 1851, no. 48, for 1,820 francs; and at the Hôtel Drouot, *Catalogue des tableaux anciens et modernes . . . dont la vente par suite du décès de Mme. C[hesnest]*, Dec. 7–8, 1908, no. 82 (ill.), for 800 francs. Jean René Gaborit graciously permitted consultation of the documentation center of the Département des Sculptures at the Musée du Louvre, Paris, which led to the discovery of these citations.

8. Letter from Canova to Quatremère, Paris, Bibliothèque Nationale, Ms. Fonds It., no. 65, fols. 122–23.

9. Antoine Chrysostome Quatremère de Quincy, *Canova et ses ouvrages ou mémoires historiques sur la vie et les travaux de ce célèbre artiste* (Paris, 1834), p. 175 and n. 1.

10. Letter from Quatremère to Canova, Mar. 16, 1811, Bassano, Biblioteca Civica, Ms. Canoviani 1690, excerpted in Pavanello (note 2), p. 118.

11. René Schneider, *Quatremère de Quincy et son intervention dans les arts* (Paris, 1910), p. 279.

12. See Gérard Hubert, "Josephine, a Discerning Collector of Sculpture," *Apollo* 106 (July 1977), pp. 40–41.

13. Schneider (note 11) , p. 45.

14. Letter from Quatremère to Canova, Feb. 27, 1813, cited in Quatremère (note 9), pp. 181–82.

15. Letter from Quatremère to Canova, Mar. 31, 1813, Paris, Bibliothèque Nationale, Ms. Fonds It., no. 65, fols. 114–15, reprinted in Quatremère (note 9), p. 388.

16. Quatremère (note 9), pp. 175–76.

17. Fred Licht, *Canova* (New York, 1983), pp. 127–30, figs. 105–106.

18. For a penetrating analysis of Canova's sculptural practice and relationship to his assistants, see Hugh Honour, "Canova's Studio Practice—I: The Early Years," and "Canova's Studio Practice—

II: 1792–1822," *The Burlington Magazine* 114 (Mar. 1972), pp. 146–59, and 114 (Apr. 1972), pp. 214–29.

19. The essential literature on Quatremère includes Joseph Daniel Guigniaut, "Notice historique sur la vie et les ouvrages de M. Quatremère de Quincy," *Mémoires de l'Institut National de France, Académie des Inscriptions et Belles-Lettres* 25, 1 (Paris, 1866); Henry Jouin, *Antoine-Chrysostome Quatremère de Quincy, deuxième secrétaire perpetuel de l'Académie des Beaux-Arts* (Paris, 1892); Henri Wallon, *Notice supplémentaire sur la vie et les travaux de Quatremère de Quincy par son successeur immédiat* (Paris, 1903); Schneider (note 11); Thomas F. Rowlands, "Quatremère de Quincy: The Formative Years, 1785–1795" (Ph.D. diss., Northwestern University, 1985).

20. For discussion of this first meeting, see Quatremère, *Canova et ses ouvrages* (note 9), pp. 34–35; Schneider (note 11), p. 370; Honour, "Antonio Canova and the Anglo-Romans, Part II: The first years in Rome," *Connoisseur* 114 (Aug. 1959), p. 225. On the *Daedalus* and *Theseus* groups, see Hugh Honour, "Canova's *Theseus and the Minotaur*," *Victoria and Albert Museum Yearbook* (London, 1969), p. 15, n. 78; and Elisa Debenedetti, ed., *Studi Canoviani* (Rome, 1973), entry by Maria Grazia Messina, pp. 210–12.

21. On the aesthetic theories developed by Quatremère, see René Schneider, *L'Esthétique classique chez Quatremère de Quincy (1805–1825)* (Paris, 1910); and Frederick Will, "Two Critics of the Elgin Marbles: William Hazlitt and Quatremère de Quincy," *Journal of Aesthetics* 14 (June 1956), p. 469. On their application to Canova, see Angela Cipriani, "L'Arte di Canova nella critica di Quatremère de Quincy," in *Studi Canoviani* (Rome, 1973), pp. 119–51.

22. Gérard Hubert, "Early Neo-classical Sculpture in France and Italy," trans. P.S. Falla, in London, Arts Council of Great Britain, *The Age of Neo-classicism* (London, 1972), p. lxxxii.

23. Quatremère de Quincy, "Reflexions critiques sur les mausolées en général, et en particulier sur celui de l'archiduchesse Christine, exécuté par M. Canova, et placé depuis peu dans l'église de Saint'Augustin, à Vienne," *Archives littéraires* 9 (Paris, 1806), pp. 266–92. See also Schneider (note 11), pp. 374, 378.

24. See René Schneider, "L'Art de Canova et la France Impériale," *Revue des Etudes Napoléoniennes* 1 (Jan. 1912), pp. 51–52.

25. See Schneider (note 11), p. 376.

26. Quatremère (note 9), pp. 46–47.

27. Ibid., p. 265.

28. For example, see Quatremère, "Notices sur M. Canova, sur sa réputation, ses ouvrages et sa statue du Pugilateur," *Archives littéraires* 3, 7 (Paris, 1804), pp. 3–24; and idem, "Sur M. Canova et les quatre ouvrages qu'on voit de lui à l'exposition publique de 1808," *Moniteur universel* 363 (Dec. 28, 1808), pp. 1,428–30.

29. The details of his nomination and eventual election are recorded in the "Registre des procès-verbaux et rapports de la classe des littérature et beaux-arts, Institut de France," *Procès-verbaux de l'académie des beaux-arts* 2 (1800/01–05), pp. 76, 78, 87, 94, 104, 118, 178–79, 190.

30. Quatremère (note 9), p. 68, wrote, "For the mob of spectators, this was something new, beyond the range of ordinary admiration, which seemed to create the effect of a miracle." And Francis Haskell, *An Italian Patron of French Neo-classic Art* (Oxford, 1972), p. 16, added: "It would be hard to exaggerate the importance that this piece of sculpture had for French taste, or the truly astonishing enthusiasm with which it was greeted by artists, critics, and connoisseurs."

31. See the letter from Canova to Quatremère, Nov. 26, 1806, Paris, Bibliothèque Nationale, Ms. Fonds It., no. 65, fol. 57; and André Fugier, *Napoléon et l'Italie* (Paris, 1947), p. 275.

32. Quatremère de Quincy, *Lettres sur les préjudices qu'occasionneroient aux Arts et à la Science, le déplacement des monumens [sic] de l'art de l'Italie, le démembrement de ses Ecoles, et la spoliation de ses Collections, Galeries, Musées, etc.* (Paris, 1796; new ed., reprinted from the original, Rome, 1815); and included in *Lettres sur l'enlèvement des ouvrages de l'art antique à Athènes et à Rome, écrites les unes au célèbre Canova, les autres au Général Miranda* (Paris, 1836).

33. The two men's roles in the restitution are discussed in Eugène Muntz, "Les Invasions de 1814–1815 et la spoliation de nos musées (Episodes d'histoire diplomatique) III: 1815—La mission de Canova et l'annulation du traité de Tolentino," *La Nouvelle Revue* 107 (July 15, 1897), pp. 193–207.

34. Letter from Canova, Dec. 9, 1815, Paris, Bibliothèque Nationale, Ms. Fonds It., no. 65, fols. 127–28, cited in Quatremère (note 9), pp. 288–89. For a general account of the reception of the Elgin Marbles, see Jacob Rothenberg, *"Descensus Ad Terram": The Acquisition and Reception of the Elgin Marbles* (New York, 1977).

35. Guigniaut (note 19), p. 400.

36. Published in the *Journal des savants* (Apr. 1823).

Thurman, "Neoclassicism on Cloth," pp. 47–53.

1. The collection—182 pieces—comprises 32 embroidered, 14 woven, and 136 printed examples.

2. For more information on the Jouy-en-Josas manufactory, see New York, The Metropolitan Museum of Art, *Painted and Printed Fabrics . . .*, text by H. Clouzot and F. Morris (New York, 1927); and H. Clouzot, *Histoire de la manufacture de Jouy . . .* 2 vols. (Paris, 1928).

3. Huet's drawing for *Cupid and Medallions* is in the Musée des Arts Décoratifs, Paris (9769).

4. The Musée des Arts Décoratifs has an impression in purple (13FF[4]-2).

5. Huet's drawing for *Cupid and Psyche* is also in the Musée des Arts Décoratifs (9756).

6. The Musée des Arts Décoratifs has an impression in red (25467); the Victoria and Albert Museum, London, has two examples in red (T1620-1899A and T332-1919); the Museum of Fine Arts, Boston, has one in purple (59.1038); and the Cooper-Hewitt Museum of Design, New York, has one in purple and yellow (1957-51-6).

7. The Musée des Arts Décoratifs has examples of this design in red and in purple and yellow (9861, 18615); the Cooper-Hewitt Museum has one in red and yellow (1965-30-1) and one (in two fragments) in red (1957-51-2 and 2A); the Philadelphia Museum of Art has one in red (29-164-97), one in purple and yellow (25-8-1), and one in purple (52-64-22); the Museum of Fine Arts, Boston, has two in purple (40.218, 56.231); and there is another in the Musée Oberkampf, Jouy-en-Josas (accession number and color not known).

8. A drawing in the Musée des Arts Décoratifs (CD2859) features the identical background pattern—a stylized floral motif enframed within a diamond shape—but its frames were left empty, which indicates that the composition was intended to incorporate a variety of subjects.

9. The Cooper-Hewitt Museum has an example of the design (in two fragments) in red (1906-15-5 and 6); the Bibliothèque Forney, Paris, has one in purple (1181133); the Museum of Fine Arts, Boston, has one in purple and yellow (52.264); and the Museé de l'Impression sur Etoffes, Mulhouse, has one in red and yellow (961.299.12).

10. The Bibliothèque Forney dates its piece (181013), which is in red, to 1804. Other impressions of this design exist in the Musée de l'Impression sur Etoffes, which has one in red and yellow (858.289.1); and in the Musée des Arts Décoratifs, which has one in blue (D1191).

11. I gratefully acknowledge the research to be published in *Textile History* (a series produced by the Pasold Research Fund, London), by Elizabeth Anne Coleman, Curator of Costumes and Textiles, The Brooklyn Museum. The images in the Chicago panel can be found in volume 5, book 3, of Cassas's publication, a copy of which is in the collection of the Canadian Centre for Architecture, Montreal (WM8985).

12. Other examples are in the Musée de l'Impression sur Etoffes, in red (961.288.2, 954.307.1-6); in the Cooper-Hewitt Museum (1977-66-1) and the Museum of Fine Arts, Boston (1973.102), in brown; and in the Musée des Arts Décoratifs, in purple (34589).

13. Other impressions are in the Musée des Arts Décoratifs, in reddish brown (15439); and in the Musée de l'Impression sur Etoffes, in red and yellow (976.248.131).

Witt-Dörring, "A Viennese Secretary in the Empire Style," pp. 55–67.

1. Devenish and Company, Inc., New York.

2. John W. Keefe, in The Art Institute of Chicago, *The Antiquarian Society of the Art Institute of Chicago. The First One Hundred Years*, exh. cat. (Chicago, 1977), pp. 15–17.

3. Jean Patrice Marandel and Simon Jervis were among the first to express doubts about the French origin of the secretary.

4. While the *secrétaire à abattant* was highly fashionable in France in the mid-eighteenth century, the Viennese produced a version related to the so-called tabernacle secretary, which was developed from the "English writing desk" (as it was called around 1720–30 in Austria). This desk type combines a chest with a central desk section which can be locked and contains interior compartments and drawers. Above this is a case piece composed of many individual drawers and a central tabernacle. This form persisted in Vienna until around 1800.

5. COMPOSE PAR C. PERCIER ET PFL FON/TAINE/MDCCCXII is stamped in the upper left quadrant on the back and center rear of base; CP ET F is stamped in the interior top left drawer, rear exterior surface, and interior bottom right drawer, rear, exterior surface.

6. Singleton family, "Black Woods" near Sumter, South Carolina (sale: New York, The Fifth Avenue Art Galleries, Nov. 16, 1905, no. 356 [ill.]).

7. Earl of Clancarty, Garbally, County Galway, Ireland (sale: London, Christie's, Mar. 11, 1892).

8. Keefe (note 2), p. 16.

9. It was published in Paris in four editions (1801, 1812, 1827, 1840). For almost two generations, the book served as the "bible" of the Empire style throughout Europe. It was used by designers, craftsmen, and manufacturers who wanted to give their products a fashionable touch. Therefore, it is rather risky to use comparisons with decorative details in this compendium as proof of Percier's and Fontaine's authorship.

10. See Georg Himmelheber, *Biedermeiermöbel* (Munich, 1987), figs. 142, 144, 230.

11. S. N. Hlopoff, restorer of the secretary in 1976, said in a telephone conversation on November 16, 1976: "They are covered with a silver leaf which was in turn covered with an oxblood with varnish which gave the impression of gold leaf." The Art Institute of Chicago, Department of European Decorative Arts, Sculpture, and Classical Art, departmental files.

12. Josephine is the stylistic term for the Austrian variety of the Louis XVI style in the last two decades of the eighteenth century. Its name is derived from the rule of Emperor Josef II (1780–90).

13. In German, the term for furniture decorations carved in wood, then gilded or bronzed, is *holzbronze*.

14. W. C. W. Blumenbach, *Wiener Kunst- und Gewerbsfreund oder der neueste Wiener Geschmack* (Vienna), no. 1 (Jan. 30, 1825), p. 2: ". . . over a number of years an attempt was made to enhance the exterior of the furniture by gilded and bronzed carvings (the so-called wooden-bronze) by affixing many mounts and decorations made of pressed and varnished tombac sheets or made of genuine gilded metal bronze. . . ."

15. *Journal des Luxus und der Moden* (Weimar) (Oct. 1806), pp. 683–84, pl. 30.

16. According to Gabriele Fabiankowitsch, who is preparing a paper on the teaching of drawing to cabinetmakers in Vienna and who has reviewed portions of the archive of the Viennese cabinetmakers' guild. The pertinent information is included in *Protokoll über die bey gesammelten Handwerken abgehandelt werdende Gegenstände und hierauf enfolgte Entscheidungen* 15 (1806–42), in the following entries:

Hiernbach, Martin: "Lady's secretary made of mahogany with bronze decorations, the inside of burl wood, the core wood consisting of oak," Jan. 17, 1811, to June 27, 1811.

Ertl, Johann: ". . . secretary made of mahogany, the core wood consisting of oak, the inside of maple, varnished red and decorated with bronze," Feb. 22, 1813, to May 5, 1813.

Körösi, Ladislaus: ". . . secretary made of mahogany with borders, the upper inside made of maple polished in red and cherry wood, the core wood consisting of oak . . . ," Dec. 7, 1813, to Mar. 13, 1814.

17. Another example is the standing desk in the Oesterreichisches Museum für angewandte Kunst in Vienna (H894). It is covered with ash wood veneer, and the individual panels of the surface are framed with pear wood stained in black. It is signed: "*Verfertigt: Von Johann Reimann bürgerl. G. Tischerlermeister in Wien den 16ten Jänner 1802*" (made by Johann Reimann, citizen master cabinetmaker in Vienna, January 16, 1802).

18. Published in *Antiquariato* 96 (Sept. 1988), p. 26, as having been auctioned May 9 at the Nouveau Drouot, Paris, room 5, by Pierre Cornette de Saint-Cyr, France.

19. See the secretary signed by Hans Brandt, 1822, in Celle (Federal Republic of Germany), Bomann-Museum; the secretary signed by Ludwig Beissner, 1829, in the Museum für Kunst und Kulturgeschichte der Stadt Dortmund; and the Thuringian secretary in New York, Didier Aaron Gallery.

20. See the collection of samples from the metal-products factory of Franz Feil, 1822, in the Oesterreichisches Museum für angewandte Kunst in Vienna (Me708).

21. On November 21, 1984, in New York, Christie's auctioned off a lyre-shaped secretary whose top portion had the shape of an organ case.

22. Auctioned on November 24, 1987, at Christie's in New York.

23. The author knows of this piece only from an advertisement by the art dealer Joachim Kratz in *Kunst und Antiquitäten* 3 (1985), p. 98.

24. There is documented proof that Johann Christian Friedrich Paulick was a journeyman working with Viennese cabinetmakers from 1811 to 1818. In 1820, he became a master craftsman, so that his school drawing must have been made prior to 1820. Stylistically, it fits the years around 1815.

25. The soft wood of the secretary has been impressed in many places with a round stamp: TISCHLERZUNFT IN KRONSTADT (cabinetmakers' guild in Kronstadt).

Roberts, "The *Londonderry Vase*: A Royal Gift to Curry Favor," pp. 69–81.

The author is deeply indebted to Mme Tamara Préaud, librarian and archivist of the Manufacture Nationale de Sèvres, who located all of the Sèvres archival materials. She would also like to acknowledge the help of Laurie A. Stein, Jeanne Long, and Rita McCarthy, Department of European Decorative Arts and Sculpture and Classical Art, The Art Institute of Chicago; and Professor Paul W. Schroeder, Professor of History, University of Illinois, Urbana.

1. Manufacture Nationale de Sèvres archives, Registre Vbb 5 (1813–19), folio 2, year 1814.

2. For contemporary accounts of the political history of this period and a modern interpretation, see *Correspondence, Despatches and Other Papers, of Viscount Castlereagh, Second Marquess of Londonderry*, ed. Charles William Vane, Marquis of Londonderry, 4 vols. (London, 1853); *Memoirs of the Prince de Talleyrand*, ed. Duc de Broglie, 2 vols. (London, 1891); Henry A. Kissinger, *A World Restored* (New York, 1964).

3. Professor Paul W. Schroeder, History Department, University of Illinois, specialist in Napoleonic history, conversation with Laurie A. Stein, July 22, 1987.

4. For a thorough eighteenth-century history of Vincennes/ Sèvres, see Svend Eriksen and Geoffrey de Bellaigue, *Sèvres Porcelain: Vincennes and Sèvres: 1740–1800* (London, 1987).

5. Soft-paste porcelain (*pâte tendre*) was developed at many factories from white clays, ground glass, and other materials; it was usually fired at temperatures under 1250 C. Lead glazes were usually applied after an initial firing; if enamel colors were used, they were given a third firing. Soft-paste bodies were developed in imitation of true or hard-paste (*pâte dure*) porcelain in instances when the arcana or secret formula was unknown. True porcelain, fired at a high temperature between 1250–1350 C, is made from kaolin or white china clay and petuntse, a feldspathic stone. Upon firing, they fuse into a durable, vitrified whole that is translucent, impervious to acids, and resistant to heat and cold. It may be glazed with a feldspathic material.

6. Original watercolor and ink drawing by Alexandre Théodore Brongniart for the *Vase étrusque à rouleaux*, Manufacture Nationale de Sèvres archives, Registre Vj'17 (1810), folio 121, March 14.

7. Paris, Musée Carnavalet, *Alexandre-Théodore Brongniart, 1739–1813, architecture et decor*, exh. cat. (1986), p. 252, no. 315.

8. Mme Tamara Préaud, letter, Feb. 25, 1986. Departmental file, European Decorative Arts and Sculpture and Classical Art, The Art Institute of Chicago.

9. *Feuille d'appréciation*, folio no. 54, Dec. 9, 1813, Manufacture Nationale de Sèvres archives, Carton P63, folder 2.

10. Mme Tamara Préaud, letter to Madeline Marsh, Feb. 26, 1986. Departmental file, European Decorative Arts and Sculpture and Classical Art, The Art Institute of Chicago.

11. Manufacture Nationale de Sèvres archives, Registre Vj 20 (1813), fols. 64, 65 verso.

12. Ibid., fol. 71.

13. Ibid., fols. 172, 172 verso, 194.

14. Ibid., fol. 185 verso.

15. Ibid., fol. 178 verso.

16. Ibid., fols. 104 verso, 105.

17. Ibid., fols. 100 verso, 101, 101 verso.

18. See Paris, Musée Carnavalet (note 7), p. 240.

90